Macke

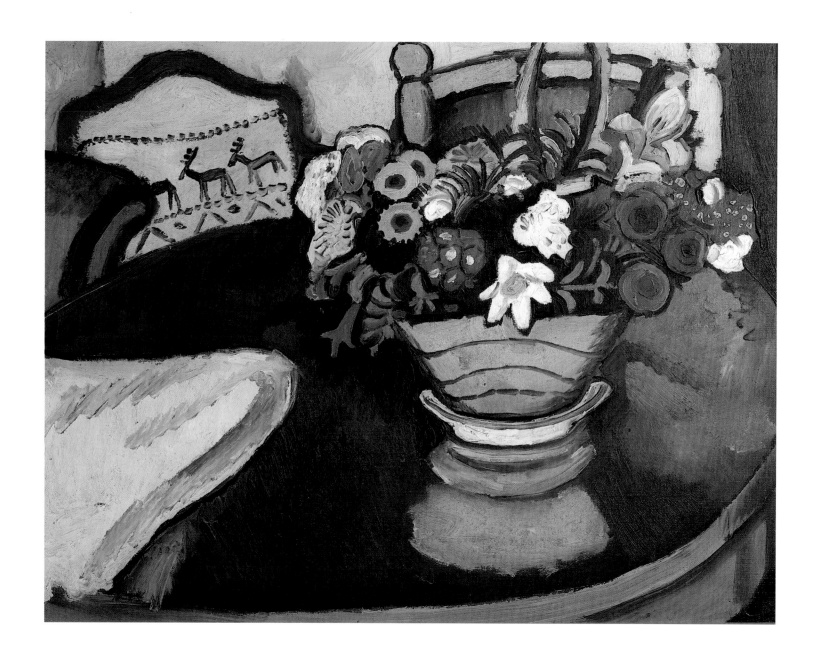

Anna Meseure

AUGUST MACKE
1887–1914

TASCHEN

KÖLN LISBOA LONDON NEW YORK OSAKA PARIS

FRONT COVER:
Detail from: *Hat Shop,* 1914
Hutladen
Oil on canvas, 60.5 x 50.5 cm
Museum Folkwang, Essen

ILLUSTRATION PAGE 1:
In the Zoological Garden, 1912
Im Zoologischen
Indian ink, 23.3 x 28.3 cm
Museum am Ostwall, Dortmund

FRONTISPIECE:
Still-Life with Stag Cushion and Flowers, 1911
Stilleben mit Hirschkissen und Strauß
Oil on canvas, 46 x 61 cm
Museum für Kunst und Kultur-
geschichte der Hansestadt Lübeck, Lübeck

BACK COVER:
August Macke and Paul Klee
in front of the Barbier Mosque, Kairuan, 1914

**This book was printed on 100% chlorine-free bleached
paper in accordance with the TCF standard.**

© 1993 Benedikt Taschen Verlag GmbH
Hohenzollernring 53, D–50672 Köln
Editor and production: Brigitte Hilmer, Cologne
English translation: Iain Galbraith
Cover:Angelika Muthesius, Cologne
Printed in Germany
ISBN 3-8228-0551-3
GB

Contents

6
Prerequisites and Origins

12
The Discovery of Impressionism

22
The Influence of the Fauvists

34
Macke and "Der Blaue Reiter"

42
Between "Abstraction and Empathy"

56
Macke and the "Rheinische Expressionismus"

60
The World View of Macke's Pictorial World

74
The Journey to Tunisia

86
The Perfection of the Unfinished

94
August Macke: Chronology

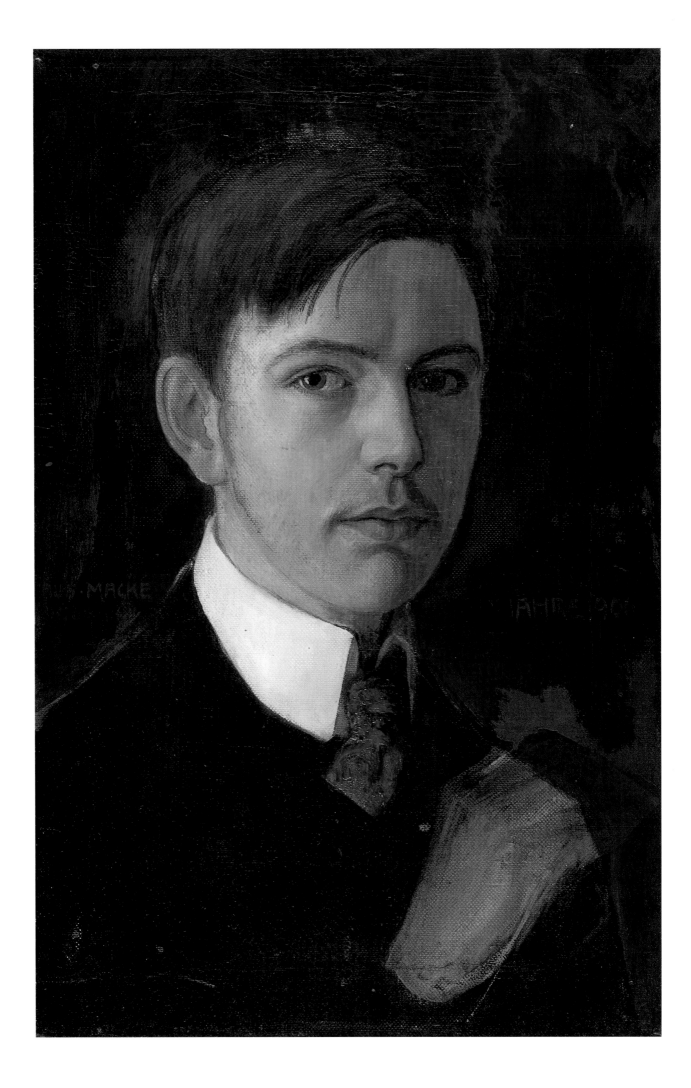

Prerequisites and Origins

Born at Meschede, Westfalia, on 3rd January 1887, August Macke was the youngest child and only son of middle-class parents. His father, August Friedrich Hermann Macke, was a civil engineer and building contractor, while his mother Florentine, née Adolph, was the austere, but energetic daughter of a farmer. His father had a strong leaning towards the arts and was unusually talented in his own right. He made drawings and collected old coins and engravings. Following the birth of their youngest child, his parents moved to Cologne, taking up their abode in a house in the Brüsseler Strasse.

In 1897, Macke went to Kreuz Grammar School. It was here that he met his school playmate and later fellow artist, Hans Thuar. Thuar's father possessed a collection of Japanese woodcuts which undoubtedly left an impression on the boy.

The Macke family's move to Bonn at the end of 1900 marked the beginning of a new chapter in thirteen-year-old August's life. In an attempt to master the familiy's financial difficulties, Frau Macke had opened a boarding-house in the Meckenheimer Strasse. Macke attended secondary school in Bonn, but was not an outstanding pupil. In her "Recollections of August Macke", one of the most important sources of information on the artist's life and work, his later wife Elisabeth Erdmann-Macke wrote: "He could think of nothing but his painting, and would simply not bother with anything which didn't fit in with his plans."

Macke first met Elisabeth Gerhardt on his way to school in 1903, when she was fifteen years old. He describes this meeting in a letter to his friend Thuar: "Hans, how lucky I am. It's quite incredible. It's too much to describe, so I'll have to be laconic. Saw real gypsy of a woman – brother in final year, so said he had amazingly interesting face. (Ended up drawing him). Thus sidled way into family. Friends (in reserves) had me swear oath yesterday to paint said woman in holidays." It seems that Macke used his acquaintanceship with her brother Walter, whom he had known since his Kreuz Grammar School days, to gain entry into Elisabeth's parental home – under the pretext of drawing Walter's portrait. From now on, Elizabeth would sit for him often; indeed, she was to become his "muse" and the archetype of all his female figures. Macke soon was a regular and welcome guest at the house of this artistically-minded family of Bonn merchants.

While still at school, Macke had seen paintings by Arnold Böcklin in the Kunstmuseum in Basel. The Swiss artist's symbolism left a deep im-

Self-Portrait, 1906
Selbstbildnis
Oil on canvas, 54.2 x 35.4 cm
Westfälisches Landesmuseum für Kunst und Kulturgeschichte, Münster
Permanent loan from private collection

pression on the sensitive boy. Böcklin became the first major influence on his artistic development. Macke grew more and more determined to become an artist – a decision which met with opposition from his father. The latter, by now almost destitute, was concerned for his only son's future and determined that he should lead a regular life.

However, Macke's plans found the support of the Cologne manufacturer Alfred H. Schütte, the father of a school friend, who enabled Macke to submit his work to the opinion of Paul Clemen, the professor of art history at Bonn, and Claus Meyer, the genre painter and professor at the Academy in Düsseldorf. It was Schütte, too, who provided the financial support for Macke's studies.

Indeed, throughout his life Macke would never be exposed to financial worries – a fact not without its significance for Macke's artistic development and the specific character of his work

Macke left grammar-school early. In October 1904 he took up his studies at the Academy in Düsseldorf, starting in an elementary class taught by the history painter Adolf Maennchen. In a letter to his former school friend Hermann Sauren, dated 26th October 1904, Macke described the routine at the Academy in his usual, jocular manner: "The whole caboodle starts at 8 o'clock and finishes at five in the afternoon. The youngest has to make the coffee, and everyone puffs away at those small English pipes while working. We draw only from so-called plaster-work junk, i.e. plaster-casts. We're learning a tremendous amount."

Presently, however, drawing from "plasterwork junk" no longer satisfied Macke and his initial enthusiasm gave way to a more sceptical attitude towards the conservative atmosphere of the Academy. Although he moved up to the painting class in a few weeks, where he would be able to take part in life drawing, Macke's dissatisfaction with the working conditions at the Academy grew day by day. Thirsting after knowledge as he did, it is therefore hardly surprising that the student eventually enrolled in Autumn 1905 for additional evening classes at the local college of applied art. "The freer atmosphere there and his day-to-day work with living forms, with plants and animals, appealed far more to him than all that dead academic stuff," reported Elisabeth Erdmann-Macke.

In 1903 the architect Peter Behrens had been appointed to Principal of the Düsseldorf College of Applied Art. He had reformed teaching at the college in accordance with the progressive ideas of the British Arts and Crafts Movement. Instead of the sterile copying of Old Masters, the reproduction of ornamental designs or the "artistic" improvement of various commodity articles, he had introduced – among other things – "drawing from appearance" (the representation of forms or objects using different techniques), and "drawing by memory" (the reproduction of forms from memory), as well as writing courses.

Macke especially liked working freely from nature. He also enjoyed Fritz Helmut Ehmke's technical classes whose progressive atmosphere stood in glaring contrast to the stuffy teaching methods of the Academy.

Full of enthusiasm, he wrote to Elisabeth: "The whole school has more of a Japanese flair about it; the teaching methods, for instance, allow you to use whatever technique you want: modelling clay, carving, etching, engraving, lithograph, book-plate drawing – or you just put gold-

Pan Eavesdropping on a Couple, 1904
Pan belauscht ein Paar
Crayon, Indian ink/pen and brush,
15.1 x 23.1 cm
Sketchbook No. 1A, p. 8
Westfälisches Landesmuseum für Kunst und
Kulturgeschichte, Münster

fish in a bowl in front of you and draw them. Everything here is far more
full of life. I need all that, besides the undoubtedly very useful but pedan-
tic drawing classes at the Academy." And a few days later he confirmed
the strength of his decision: "That was a good idea of mine to come to
the College here. I really like the teaching. One of the teachers told me I
had a peculiar gift for stylising plants and that I should already be using
the best paper so that the things I have done in the last few days can be
exhibited."

But Macke also was inspired by his work at the Düsseldorfer Schau-
spielhaus, whose direction Louise Dumont and Gustav Lindemann had
taken over in 1905. He had been introduced to this circle of engaged and
progressively-minded theatre people by the writers and dramatic advisers
Wilhelm Schmidtbonn and Herbert Eulenberg. "These were completely
new surroundings for August," wrote Elisabeth of Macke's new work
and circle of friends, "the whole way of life of these people was so much
more lively, and also more modern, than that at the Academy or art col-
lege. He particularly liked going to Dumont and Lindemann's house.
They had created a luxurious and comfortable home for themselves out
in Oberkassel. Later, he visited them as frequently as if he were one of
the family." At that time, the newly constructed Düsseldorfer Schauspiel-
haus was the first theatre in Germany to have a revolving stage, permit-
ting entirely new, avant-garde productions. Macke designed stage sets
and costumes for Wilhelm Kratik's Nativity play "The Mystery of the
Birth of the Saviour", for Emil Alfred Hermann's "Little Red Riding
Hood", for Shakespeare's "Macbeth", Aeschylus' "Oresteia" and So-
phocles' "Oedipus". In designing scenery for the Nativity play and "Red
Riding Hood", Macke exploited the possibilities offered by the new re-
volving stage. In fact, he was altogether enthusiastic about the latest, anti-
illusionist conception of stage design: "You wouldn't believe how much
I'd enjoy putting something completely new on the stage, for today's

theatre is more lacking in style than ever before. All that cardboard dec-
oration and painted scenery – it all has to go. What I'd do is create
moods using colour and curtains alone, without copying nature. Art
today is not nature. Style is called for. People make far too much of
décor." However, when he was offered the position of artistic director of
the theatre association "Die Bühne", he declined. For although work at
the Schauspielhaus interested him, his desire to set up as an artist finally
prevailed.

Macke's first artistic attempts date from the year 1902. He was then
but a fifteen-year-old grammar-school boy, and yet his drawings, mostly
landscape and animal studies, already show a remarkable talent, surpris-
ing us with the artist's pronounced tendency to reduce his subjects to
their essence. He had filled his first sketchbook in January 1904 in Bonn,
even before starting at the Düsseldorf Academy. Macke's passion for cap-
turing the fleeting images of his daily environment seem to have made
him want to record everything that happened in his notebooks. In his
short life he was to fill a total of seventy-eight sketchbooks with more
than three thousand pages, most of which he used on both sides. The im-
portance Macke attached to his drawing can be ascertained from a letter
he wrote to his mother in 1904: "When I'm on the street I almost always
have my sketchbook to hand. This will help me learn how to do animals
and people properly. That's something no professor can teach you – and
yet it's the most important thing of all."

The little drawings from the series of allegorical and mythological
scenes in his first sketchbook still betray the influence of Böcklin.
Macke's interest in Böcklin's gloomy fantasies full of mythological
figures comes to the fore here. In his drawing *Pan Eavesdropping on a
Couple* (p. 9), Macke uses an incident from the early stages of his rela-
tionship with Elisabeth – a tramp had apparently caught the young
couple unawares while they were out for a walk. In setting it against a
mythological background, Macke follows Böcklin's manner of turning a
relatively insignificant experience into a highly meaningful scene.

The symbolist works of Max Klinger and the naturalism of Hans
Thoma and Wihelm Leibl were also important influences on Macke at
the outset of his artistic career. He had become well acquainted with the
work of these artists through his visits to museums in Munich.

Anglers on the Rhine, 1905
Angler am Rhein
Oil on pasteboard, 40.3 x 44.5 cm
Städtische Galerie im Lenbachhaus, Munich

Among the few surviving oil paintings from Macke's years at the
Academy in Düsseldorf, it is worth mentioning a *Self-Portrait* (p. 6) of
1906 which betrays the artist's considerable indebtedness to the painting
of the 19th century and to the artists who influenced him at the time, es-
pecially Böcklin. This portrait of the nineteen-year-old was never com-
pleted. It shows the three-quarter profile of a young man with watchful
eyes against a black-red, iridescent background. His raised, but unfin-
ished, right hand suggests he is holding a paintbrush. The light is pro-
jected directly onto his face, revealing the sensitive gaze of the artist-to-
be.

In November 1906 Macke left the Academy, whose educative poten-
tial he had outgrown, and which now was unable to provide the least
stimulus for his work. From now on he intended to fathom the vast and
unknown depths of art in his own, free way.

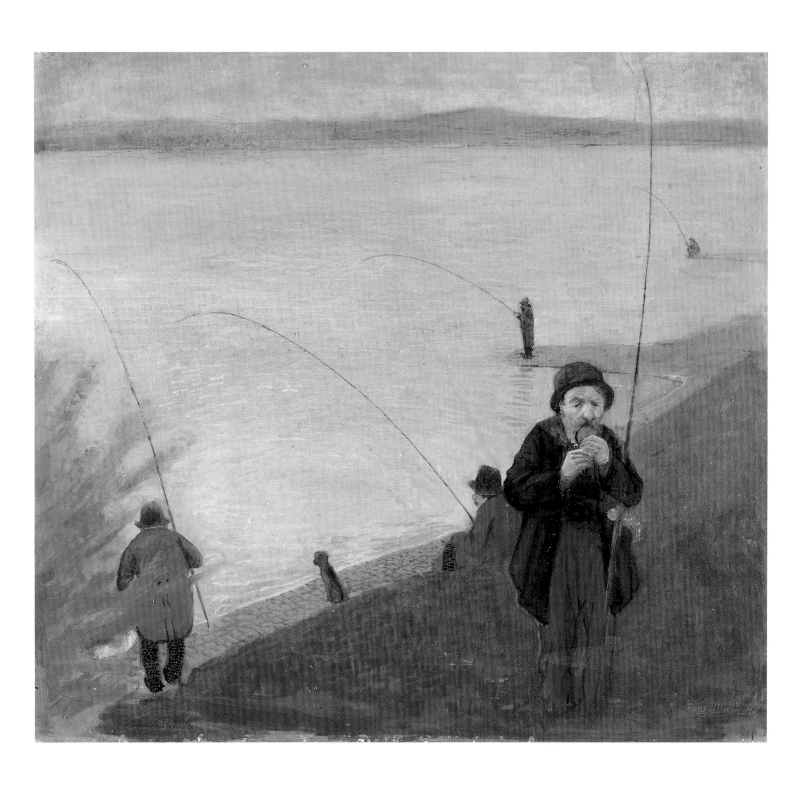

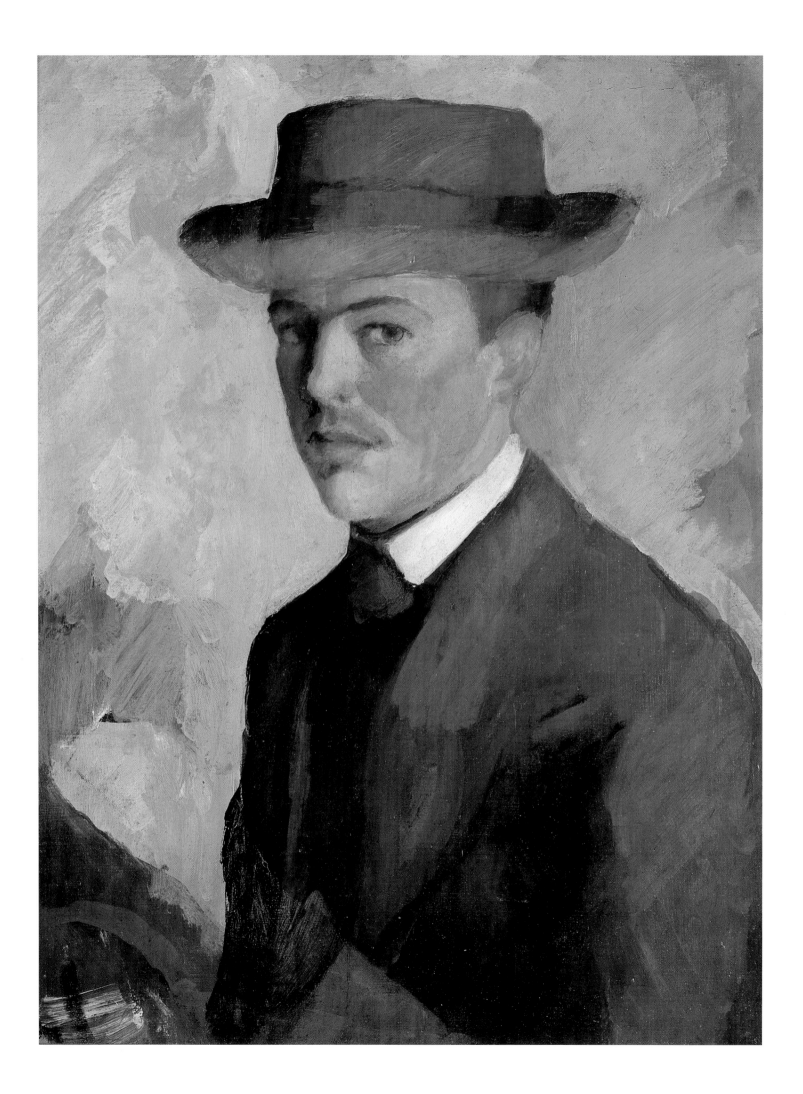

The Discovery of Impressionism

Whereas Impressionist painting was already established in France by the end of the 19th century, its importance had hardly been registered in Germany at the beginning of this century; at least, this new, atmospheric "art of light" had certainly not won acceptance in the academies. The "French moderns", as the Impressionists were called in Germany at the time, were met with suspicion by German galleries and museums, and their initial renown was largely restricted to the readership of several avant-garde publications.

Macke, too, had become acquainted with the Impressionists – through Julius Meier-Graefe's books "The Impressionists" and "Manet and his Circle", which he had bought in 1907 at the Kunsthalle in Basle. During that year, Macke made several visits to Kandern in the Black Forest. The Hotel Krone at Kandern belonged to his elder sister Ottilie, and Macke and his painter friend Claus Cito were painting one of the rooms there. From here, the two friends undertook expeditions to Basle. In the print-room at the Kunsthalle in Basle Macke also encountered photographs of works by Impressionists.

His discovery of Impressionism, though initially made indirectly through the medium of books and photographs, had a lasting effect. The Impressionists not only guided Macke's development from now on, but led him to distance himself from the artists who had hitherto influenced his work. In a letter to Elizabeth from Kandern, Macke reports on his break with the ponderous symbolism of Böcklin: "Imagine, Böcklin means nothing to me now. When I was last in Basle, I hardly looked at his things. (. . .) His paintings all seem so full of pathos, so far-fetched and confused, I can't bear them any more. (. . .) It all results from my having got to know the French painters from photographs in the print-room in Basle. (. . .) I can't understand how I managed to hang on to Böcklin so long, or onto Thoma's emotionalism. But then it's always best to go slowly – and surely. I'm rid of them for ever now."

Macke was particularly impressed by Éduard Manet's way of seeing and painting: "Manet paints women with white, glowing skin – full of life; his own soul is so full of poetry that he doesn't need to make water nymphs of them."

With his enthusiasm for the reproductions, it is hardly surprising that Macke desired to test his reactions to the originals as soon as possible. He quickly made up his mind to travel to Paris. He had planned to stay there for one week, but, thanks to the financial support bestowed upon

"In order to paint one must be able to see an object in its uniform tone, in its whole magic, be it a flower or a human hair. All the paintings created this way are the mirrors of a soul in harmony. It is quite simply vast and has no need of symbols in order to paint the sea."
August Macke

Self-Portrait with Hat, 1909
Selbstporträt mit Hut
Oil on wood, 41 x 32.5 cm
Städtisches Kunstmuseum, Bonn
Permanent loan from private collection

Avenue with Coaches, 1907
Allee mit Kutschen
Chalk and pencil, 12.2 x 18.7 cm
Sketchbook No. 6 A, p. 55
Westfälisches Landesmuseum für Kunst und
Kulturgeschichte, Münster

him by Bernhard Koehler, an uncle of Elisabeth's with whom he had not yet become acquainted, Macke was able to spend almost a whole month in the French art metropolis. Koehler, a Berlin industrialist and art collector, would remain Macke's most important sponsor and collector for as long as he lived.

Macke, fond of life and the pleasures of the senses, experienced his first sojourn in Paris as a form of inebriation. No sooner had he arrived, than he rushed to the Louvre to see a commemorative exhibition of the painter and graphic artist Eugène Carrière, who had died in 1906. The works of the Impressionists in the Galerie Luxembourg and Galerie Durand-Ruel affected him deeply: "I'm getting to like the Impressionists more and more – especially Manet", he wrote to Elizabeth on 19th June 1907. Only a few days earlier, he had gone into raptures after a visit to the Louvre: "There was one Manet I saw among all the Titians, Rubens and van Dycks – oh I can tell you, it was divine!"

Edgar Degas' pastels and Henri Toulouse-Lautrec's matchless portrayals of society inspired Macke to produce his own studies and sketches of the world of cabaret and theatre in Impressionist manner. The gay, urban bustle of the Parisian boulevards, parks and avenues and the depiction of outdoor figures now moved more into the foreground of Macke's oeuvre; indeed, they were to become one of his central themes, as countless drawings in his sketchbooks testify. A typical example is the page containing *Avenue with Coaches* (p. 14), executed in 1907 in pencil and chalk. In hurried, though bold and broad strokes, which also have a light, crumbly effect, Macke succeeds in fully capturing this everyday street scene. The blurred shapes of coaches glide past a rhythmically structured row of trees, opposite which there is a vague suggestion of facades. Despite the bare economy of its means, the scene is highly atmospheric. Like Manet, Monet, Degas and Pissaro in their sketches, or Seurat in his masterly drawings, Macke is interested here in the fleeting appearance of things, and in capturing spontaneous impressions. In so doing, his observations

are not restricted to forms; he also describes situations and tells little stories. With a sure eye for what is typical and essential, Macke records street scenes, fashionably dressed ladies at the table of a café, or pedestrians; his pencil catches momentary glimpses of everday incidents (p. 15).

His first stay in Paris was extraordinarily important for Macke's artistic development; firstly, it led to his discovery of the primacy of light and colour; secondly, it encouraged him to turn to themes from modern street and town life – subjects which also interested the Impressionists.

Between returning from Paris and continuing home to Bonn, Macke stopped over for several weeks in Kandern, where he experimented in his own work with ideas which had sprung from his encounter with the plein-air painting of the French Impressionists. Macke now also preferred painting out of doors. That year, in summer 1907, he painted the small sketch in oils entitled *Tree in the Corn Field* (p. 16) directly from nature. The motif of this oil painting is restricted to a small number of objects, avoiding narrative and drawing its energy entirely from the intense concentration of its colours. A thin, glaring strip of deep blue sky

Ladies at Table in Café or Restaurant;
People on the Street, 1907/08
Damen am Tisch im Café oder Restaurant;
Leute auf der Straße
Crayon, both 19.5 x 12.3 cm
Sketchbook No. 14, p. 47, 48
Westfälisches Landesmuseum für Kunst und
Kulturgeschichte, Münster

extends above a rich yellow, sun-drenched field of ripe corn. A tree with
a violet trunk, whose green crown is interspersed with touches of brown,
dominates the centre of the picture and casts a violet shadow beneath the
high sun. A peasant woman is standing in the shade to the right of the
tree holding the suggestion of a sickle, while in the foreground to the left
a man is busy binding a sheaf of corn. It is as if the heat of the summer
has brought everything to rest, dissolving nature and humans into one.
The sole dynamic quality is provided by the brilliant colour, whose shrill
tones dominate the painting. The paint has been applied spontaneously;
though it covers the entire surface of the painting, its texture suggests a
hurried sketch. The colour surfaces seem almost independent of one an-
other; they are employed as abstract elements of style – like sounds or
chords, in analogy to music.

 While still in Paris, Macke had decided to deepen his knowledge of
painting by studying under a leading representative of Impressionism.
His choice fell upon the Berlin Secessionist Lovis Corinth. Although Co-
rinth was considered one of the leading exponents of German Impress-
ionism, his figure paintings and portraits lacked that lightness of touch

Tree in the Corn Field, 1907
Baum im Kornfeld
Pencil, oil on cardboard, 30 x 35.8 cm
Museum am Ostwall, Dortmund

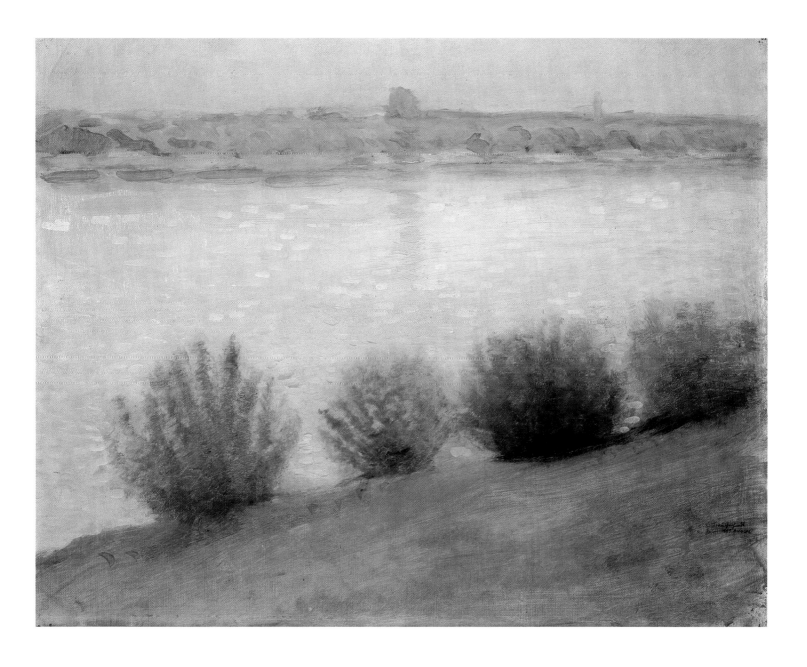

The Rhine near Hersel, 1908
Am Rhein bei Hersel
Oil on canvas, 40.5 x 50.5 cm
Städtisches Kunstmuseum, Bonn

which Macke had so cherished in the French Impressionists. It must be assumed that his choice was influenced by considerations of a pragmatic nature, since he could rely on comfortable living quarters with a friend in Berlin, and Elisabeth's uncle, Bernhard Koehler, whose generous support Macke enjoyed, also lived there.

In October 1907 Macke entered Corinth's atelier. However, his stay in Berlin was to last only a few months. The corrective advice of the respected Berlin painter was of considerably less importance to Macke than the multifarious impressions he gained of the city, with its hustle and bustle and gay nightlife. He proceeded to capture these in numerous sketches, thus continuing and intensifying the Impressionist studies he had begun in Paris. At the same time, his many visits to Berlin museums drew his attention to Renainssance art, some of whose greatest works he admired in the Kaiser Friedrich Museum, and copied in his sketchbooks. A painting by Honoré Daumier in the French Room at the National Gallery and a visit to an exhibition of modern French painting at the Galerie Schulte, where Macke first saw paintings by Paul Gauguin, confirmed Macke in the path he had chosen for himself in Paris.

Though Macke produced a large number of drawings in Berlin, very few paintings are known from this period. It is worth mentioning a small picture in oils entitled *Anglers on the Rhine* (p. 11), which he may have painted in Berlin in 1907 – in memory of his beloved homeland in Bonn, and of his walks with Elisabeth. This painting is a vivid testimony to the various influences on Macke's work at the time, but also to his highly individual transformation of those influences. Placing an old, bearded angler, wearing a bowler hat and stuffing a pipe, as a repoussoir right in the foreground at the edge of the painting, Macke directs our gaze out across a wide river landscape. The course of the river, a gentle diagonal from left to top right, is crossed by the anglers' rods. Distance is suggested by the foreshortening of the warping dams, which jut out into the river, and upon which the anglers are standing or sitting. There is the mere suggestion of a chain of hills on the horizon. The strictly coherent colouring allows only a very gradual shift in tone from green to grey and blue, and then to black; only the red handkerchief poking out of the angler's left jacket pocket provides a small accent of colour.

The simple organisation of the composition is reminiscent of Japanese models; of coloured woodcuts by Katsushika Hokusai, for example, whose fifteen volume publication "Mangwa" Bernhard Koehler had given to Macke as a present on his arrival in Berlin. The dark outlines of the figures also suggest Far Eastern influence. Elements of Impressionist origin are also unmistakable, however; the flaky brushwork of the bush in the left foreground, for example, or the atmospheric reflections on the water. The almost grotesque caricatures of the fishermen probably owe much to the stimulus of Daumier or Toulouse-Lautrec. In a letter to Elisabeth, dated 22 December 1907, Macke confesses: "(. . .) his (Toulouse-Lautrec's) spirit has been my constant guide in this city of grotesque facial expressions and gestures. His and Daumier's."

His indebtedness to Impressionist models is even more evident in *The Rhine near Hersel* (p. 17), a painting dated 1908. Here, too, in a composition reminiscent of Manet's landscape impressions, the course of a river slopes gently down to the bottom left of the picture. On the riverbank, there are four bushes, painted in a softly dabbed, blurred manner. Their hues of reddish-brown contrast with the yellow of the foreground, while the slight shimmer on the bright surface of the water corresponds to the light sky. Monet's intensive plein-air studies of one motif in different light conditions and at different times of day and year probably served as a model for this painting. For Macke also concentrates entirely upon the play of light and colour, neglecting the external form of the objects he is painting.

Before entering his one-year military service in the "Bonn Battalion" on 1st October 1908, Macke undertook several further journeys in order to deepen his knowledge of Italian and French art. In the spring of that year, he travelled to Italy with Elisabeth and her family. In the summer, he visited Paris with Elisabeth and Bernhard Koehler, to acquire works by French painters for Koehler's collection. Full of enthusiasm, Macke introduced his fiancée to the art treasures in the Paris museums. In the Durand-Ruel, Bernheim-le-Jeune and Vollard galleries, they saw pictures by Corot, Manet, Monet, Sisley, Pissarro and Cézanne. The climax of

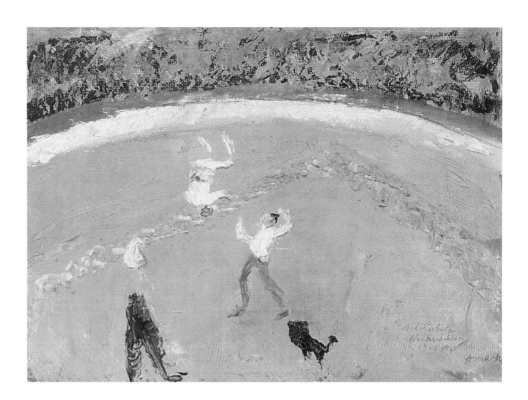

Somersaults at the Circus, 1908
Saltomortale im Zirkus
Oil on canvas, 17.7 x 24.7 cm
Private collection, Berlin

their stay was a visit to the private collection of the art critic Félix Fé-
néon, where Macke saw pictures by the Neo-Impressionist Seurat, in-
cluding "La Grande Jatte" and "Le Chahut". Although these major poin-
tillist works, with their strict, almost geometrical organisation and
surface structures of dots of unmixed colour, did not influence Macke's
work directly, they opened his eyes to new developments in painting, to
tectonic methods and the synthetic abstraction of forms.

Macke found little time for art during his military service. He prob-
ably completed the painting *Somersaults at the Circus* (p. 19) at Christ-
mas 1908. His countless sketches and drawings of the circus and variety
show prove that these themes had fascinated Macke since his first visit
to Paris in 1907. His sketchlike presentation in this circus painting ap-
proximates very closely to an Impressionist style. Its composition, espe-
cially, reveals the influence of Manet's depictions of bullfights. Macke
had become acquainted with these through Maier-Graefe's book. He
may also have seen the originals in the Durand-Ruel collection. With its
thickly applied paint, Macke's picture shows three acrobats in a ring.
Like the arenas in Manet's pictures, this describes a large arc, enclosing
almost three quarters of the painting's surface. The figures are conveyed
sketchily, using only a few stokes of the brush. The crowd in the back-
ground, too, is merely suggested by several touches of paint. Like
Macke, Picasso had modelled his "Bullfight" of 1901 on Manet's
example, while Manet himself had been inspired by motifs in Goya's
etchings.

Directly after August's release from military service, he and Elisabeth
were married. Their honeymoon, in October 1909, found the young
couple once again in the French metropolis. During their almost four-
week stay, Macke painted his impressive *Self-Portrait with Hat* (p. 12).
In her memoires, Elisabeth writes: "The comfort of life in our boarding-

house increased August's desire to paint, and so he bought various prepared boards. The result was his well-known Paris self-portrait with a hat, which he painted in our little room standing in front of the mirror." Like his self-portrait of 1906 (p. 6), this, too, appears to have remained unfinished. However, this "apparently unfinished" quality could also be seen as a new stylistic device. This three-quarter portrait, and, more especially, the colourfulness of its yellow-brown tones, reflect Macke's interest in the painting of Cézanne. The individual facets of the picture surface are constructed tectonically using generous brushstrokes. At the same time, the calculated balance of the picture's structure has already moved far beyond the lighter, and more direct manner of Impressionist compositions.

The painter Carl Hofer, who lived in Paris at the time, had drawn Macke's attention to Cézanne. It was he, too, who advised Macke to settle in Paris.

In the end, however, the Mackes followed an invitation to spend some time with the writer Wilhelm Schmidtbonn, who lived at Tegernsee. Perhaps this decision was the result of Macke's peculiarly pragmatic sense of convenience; perhaps it reflected the couple's desire to exchange their hectic life in the city, temporarily at least, for the peaceful comfort of life in the country. On 31st October 1909, they arrived at the Villa Brand in Tegernsee, where they stayed with the Schmidtbonns. Later, they moved to the house of a master joiner called Staudacher, since relations between the oversensitive poet and the Mackes, with their unrestrained joie de vivre, soon proved problematic.

His year at Tegernsee was one of the first peaks in the young artist's career. It was above all the peaceful, rural surroundings, along with the happiness of his domestic situation, which allowed him a period of intense, undisturbed work. In that year alone, he produced some two hundred paintings. But his stay there was not only productive; it also helped him attain clarity, and greater maturity, in his style.

His first work at Tegernsee was still entirely indebted to the Impressionists. A particularly lovely example of this is his pastel *Elisabeth Gerhardt, Sewing* (p. 21) of 1909 , closely modelled in both technique and style on work by Degas.

While he was still living at Tegernsee, however, Macke's work was subjected to a process of radical reorientation. His intensive and critical study of Cézanne's art, and, more especially, his personal discovery of the work of Henri Matisse, led him to distance himself from Impressionism. Macke was now ready to contribute to the great innovations of his time, and to emerge as a twentieth-century artist.

Elisabeth Gerhardt, Sewing (Girl Sewing),
1909
Elisabeth Gerhardt, nähend (Nähendes Mädchen)
Pastel, 53(52) x 41.5(42.5) cm
Galerie Utermann, Dortmund

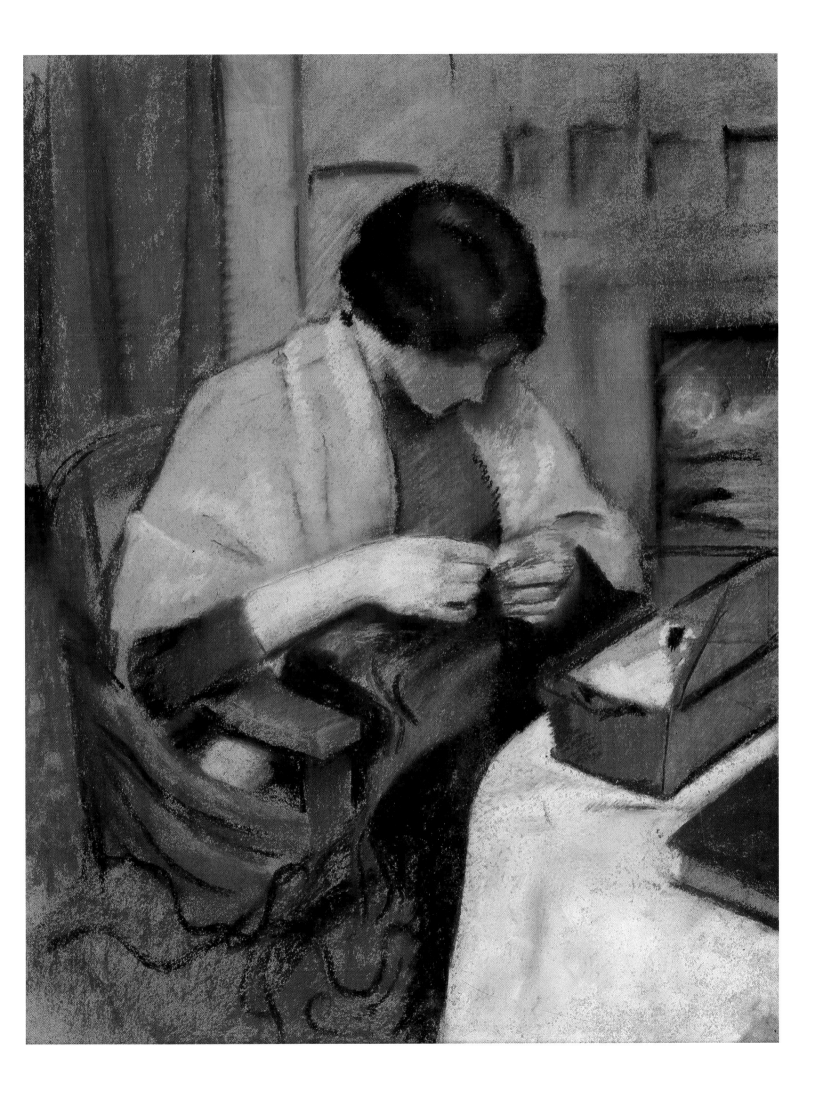

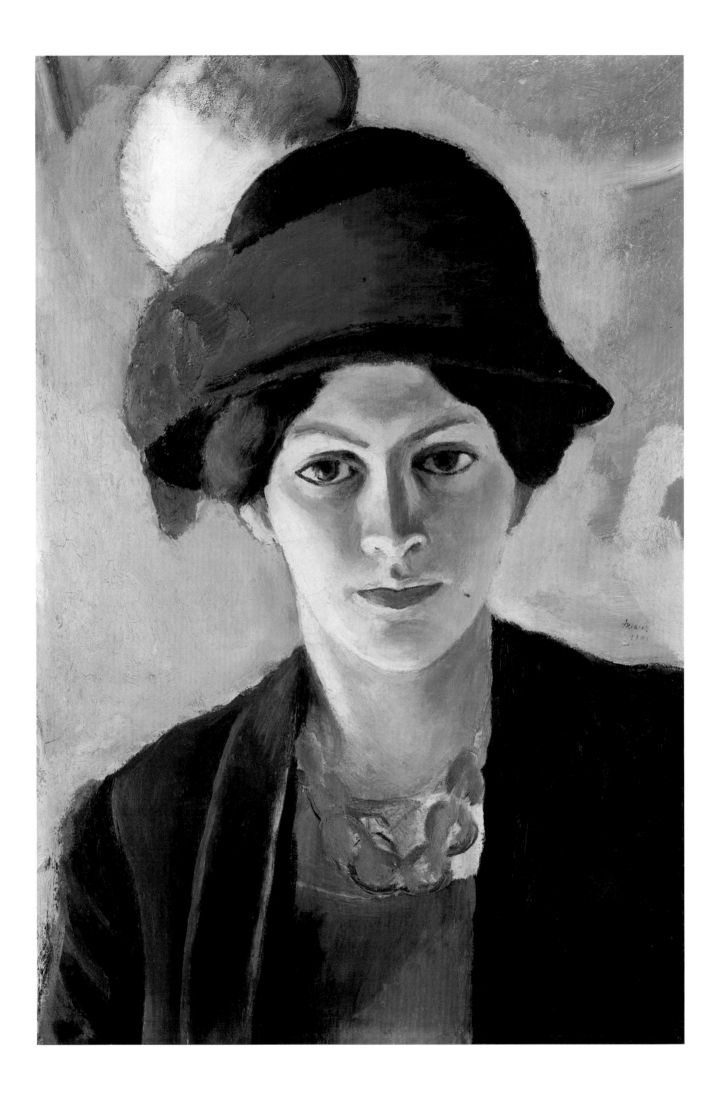

The Influence of the Fauvists

In 1905, a group of artists presented their work at the Salon d'Automne in Paris. Their renouncement of plasticity and three-dimensionality, and their tendency to compose paintings in flat, unbroken planes of luminous, or "gaudy", colour, won these artists the derisive name "Les Fauves" – the "Savages", or "Wild Beasts". The leading representatives of this new style were Henri Matisse, André Derain, Maurice de Vlaminck, Raoul Dufy and Kees van Dongen.

Reacting from the Impressionists, who were interested in the optical appearance of objects under different light conditions, and whose painterly analysis of phenomena had led to the dissolution of objects and areas of colour, the Fauvists composed their paintings as deliberately synthetic and decorative arrangements, using distinct contours and emphasising colour-planes. The works of Matisse especially, with their clearly distinguished flat areas, their intense colours and bold, ornamental simplification and abstraction of form, attracted considerable attention.

It can probably be assumed that Macke, an interested observer of developments in the art world, became acquainted with the Fauvists while they were still highly controversial, during his third visit to Paris in 1909, although neither his letters nor his sketchbooks confirm this supposition. Towards the end of 1909, Macke appears increasingly to have consolidated the structural organisation of his paintings, and to have turned to a more vivid use of colour. Even if these characteristics do not directly reflect Fauvist conceptions of painting, they reveal the influence of artists whose work can be said to have paved the way for Fauvism – van Gogh, Gauguin, Seurat and Cézanne.

Macke first saw original paintings by Cézanne in the Vollard Gallery in Paris in 1908. With Carl Hofer's guidance, his interest in Cézanne increased during his third visit to Paris. At Tegernsee, he discussed the special qualities of Cézanne's art with his cousin Helmuth. Helmuth Macke was an artist himself, and a great admirer of Cézanne.

Macke painted two enchanting portraits of his beautiful young wife at Tegernsee during the last months of 1909. While these works are clearly indebted to Cézanne, they also reveal elements of Fauvist technique. In her "Recollections of August Macke", Elisabeth writes of these: "He painted two portraits of me during that first period: one wearing a lilac dress and a green velvet hat, which he had painted down to knee-height, but had then repeatedly cut until only the head remained; the other was the lovely portrait with the apples".

Girl at Fence, 1907
Mädchen am Zaun
Woodcut

Portrait of the Artist's Wife with Hat, 1909
Porträt: Frau des Künstlers mit Hut
Oil on canvas, 49.7 x 34 cm
Westfälisches Landesmuseum für Kunst und
Kulturgeschichte, Münster
Permanent loan from private collection

The apparently consummate *Portrait of the Artist's Wife with Hat* (p. 22) thus originally began as a three-quarter-length portrait which subsequently was cut, and shortened to half-length. It shows Elisabeth, elegantly dressed in a lilac coat with a green-blue hat and orange-coloured bead necklace, before an iridescent, light blue background. Her left shoulder and the whitish plume of her hat are cut off by the edge of the picture. The beautifully sensitive features of her finely drawn face are lit from an invisible source at bottom left. The pearly tint of her skin stands out against the frame of her hair and hat, and against the collar of her coat. Compared to the finely modelled plasticity of the face, the differentiation of her dress is considerably less refined; presented in broad, flowing areas of colour, it contrasts sharply with the light background. Here, Macke creates a unique interdependence of light and dark, corporeal plasticity and flat incorporeality. The painting is a highly individual artistic achievement, in which Macke combines the influences of older masters, such as Degas, Manet and Cézanne, to arrive at a synthesis which is unmistakably his own.

In *Portrait with Apples* (p. 25), the wife of the artist, wearing a blue dress and white stole, stands before a dark background. The frontal three-quarter figure is positioned slightly left of centre, and is counterbalanced on the right by a draped yellow curtain. Elisabeth fondly remembers the genesis of this painting: "He had constructed a platform for the purpose, and had hung some material from the ceiling, gathered up like a curtain to serve as a decoration. Owing to my condition at the time, I was unable to stand for very long, and so he placed a chair on the platform for me to sit on. I have very pleasant memories of those sittings; I felt so much part of the work itself, and then, sometimes, the little thing inside me would announce its presence with a gentle knocking – a blissful feeling for a young woman."

Macke shows us a pregnant woman entirely absorbed in her own thoughts. She stands with her eyes slightly lowered, holding a plate of apples. Her pale face is framed by her thick black hair, and is enclosed by a dark ground. Her face does not so much appear to be lit, as to shine from within – an impression accentuated by the dark background.

The composition is defined by large areas of colour bounded by gently curving contours. The impressionistic application of colour, still partly in evidence in *Portrait with Hat,* has given way here to a more generous, broader brushstroke. The structure of the surface of the yellow curtain is reminiscent of the rhythmically organised, tectonic landscape compositions of Cézanne, and even the fruit-bowl, with its rhyming, and mutually enhancing colours, could almost have been lifted directly from a still-life by Cézanne. The emphasis placed on such formal elements as colour, linearity and spacial organisation also shows that Macke was beginning to grapple with Fauvist ideas in painting. However, he was not to see a large Matisse exhibition until the end of 1910 at the Thannhauser Gallery in Munich. Macke was enthusiastic, and felt confirmed in the direction his own work had taken.

Macke saw Matisse as his great mentor in the use of pure colours. The paintings of both artists employ Japanese elements of composition and construction, and both tend also to simplify form as much as

Portrait with Apples: Wife of the Artist, 1909
Porträt mit Äpfeln: Frau des Künstlers
Oil on canvas, 66 x 59.5 cm
Städtische Galerie im Lenbachhaus, Munich

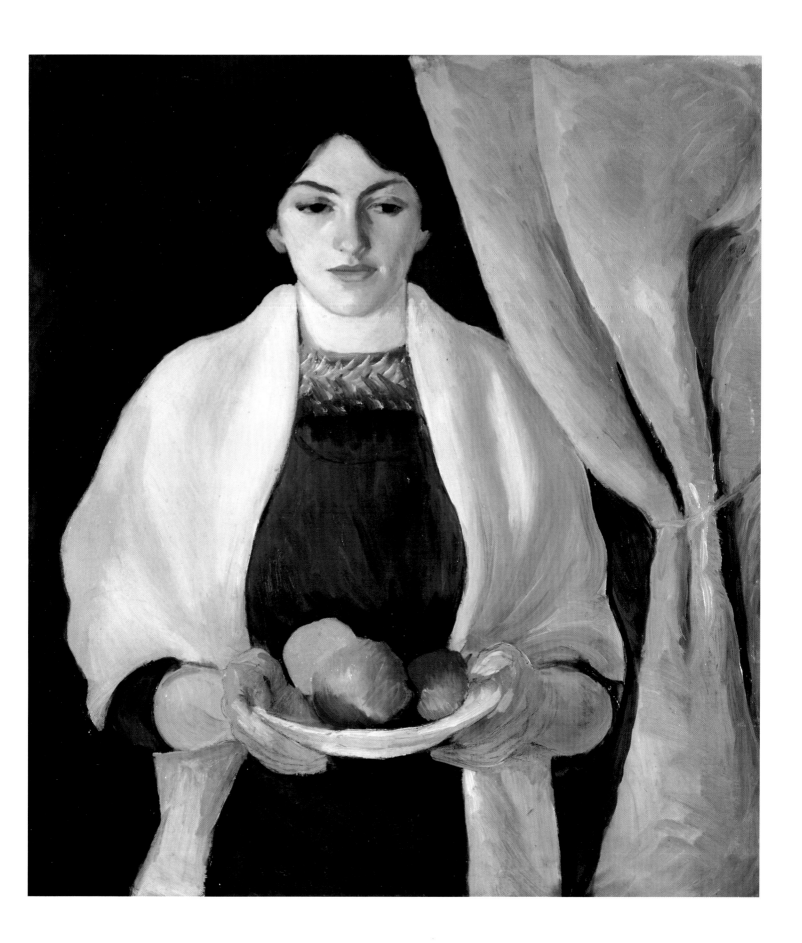

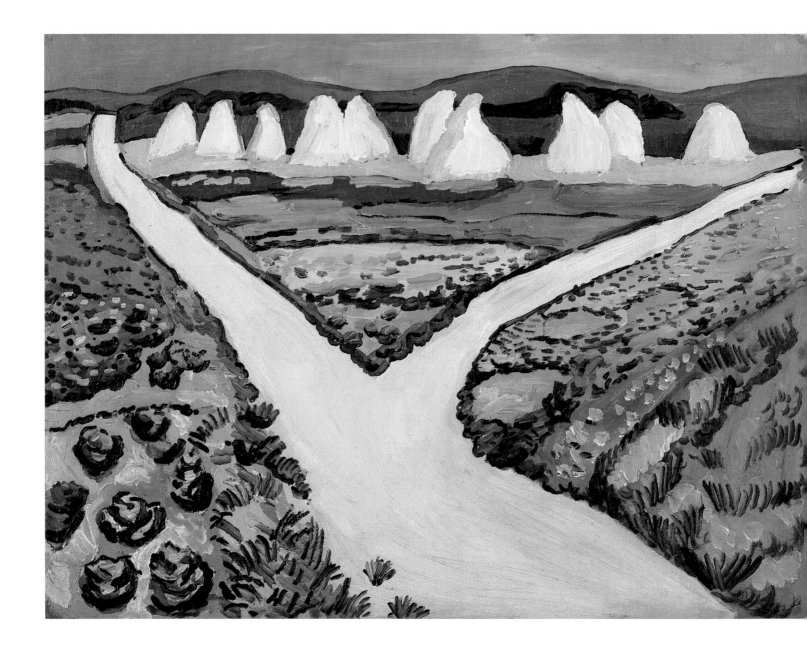

Vegetable Fields, 1911
Gemüsefelder
Oil on canvas, 47.5 x 64 cm
Städtisches Kunstmuseum, Bonn

possible. Their essential affinity, however, did not merely lie in formal and stylistic approximation, but was based on a correspondence between their whole ways of thinking, and their attidudes toward art.

Matisse set forth his own intentions in an essay entitled "Notes of a Painter", which was published in German in the magazine "Kunst und Künstler" in 1910. "Anything which is not necessary in a picture," Matisse writes, "is damaging for that very reason. A work of art has its own harmony: any superfluous detail would lead to the suppression of a more essential detail in the eye of the beholder."

In his painting *Woman Embroidering in an Armchair* (p. 30) of 1909, Macke followed the principles of Matisse, attempting to render his subject as simply as possible. The composition is divided into large areas of colour with little depth or differentiation between the individual planes; the presentation of the facial features and hands is schematic.

We also find him restraining all elaborate description in his paintings of nudes, to which he devoted considerable attention during the Tegernsee period. In his *Nude with Coral Necklace* (p. 28) of 1910, the rounded solidity of the body is contained by curved, broad contours, giving the

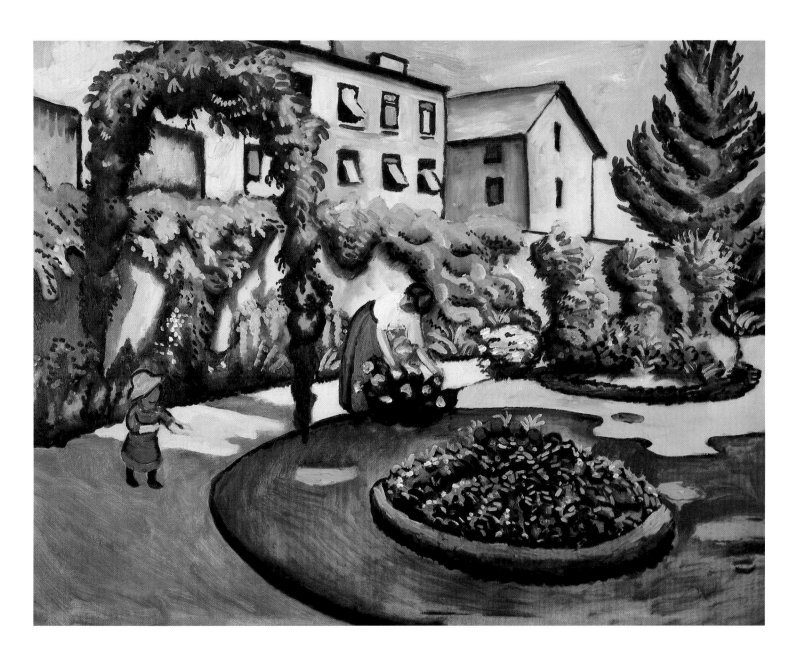

Garden Picture (The Mackes' Garden in Bonn), 1911
Gartenbild (Der Mackesche Garten in Bonn)
Oil on canvas, 70 x 88 cm
Westdeutsche Landesbank Girozentrale,
Düsseldorf

figure the appearance of a compact whole. The light from the left accentuates the forms of the body and lends them plasticity. The necklace motif recurs in the central figure of *Three Nudes against a Blue Background* at the Lenbachhaus in Munich, painted in the same year. Although in type, the figure is that of Elisabeth, Macke is not concerned here with the portrayal of a person. He is interested in the means of presentation themselves: the figure-ground relationship and the interplay of colour and surface. In *Sitting Nude with Cushions* (p. 29), too, the figure is merely a vehicle for painting, and for Macke's attempt to solve the problems of form and method – even if the solutions he arrives at here still seem appear conventional. Only gradually did Macke succeed in formulating a more radical response. The more he restrained his use of illusionistic, spacial devices, and the more he emphasised, instead, the organisation of his pictures into flat areas, the more intense his use of luminous colours became.

The painting *Staudacher's House at Tegernsee* (p. 32) was probably completed in the summer of 1910. It betrays Macke's intensive study of Matisse. The almost quadratic picture shows the hundred-year-old farm-

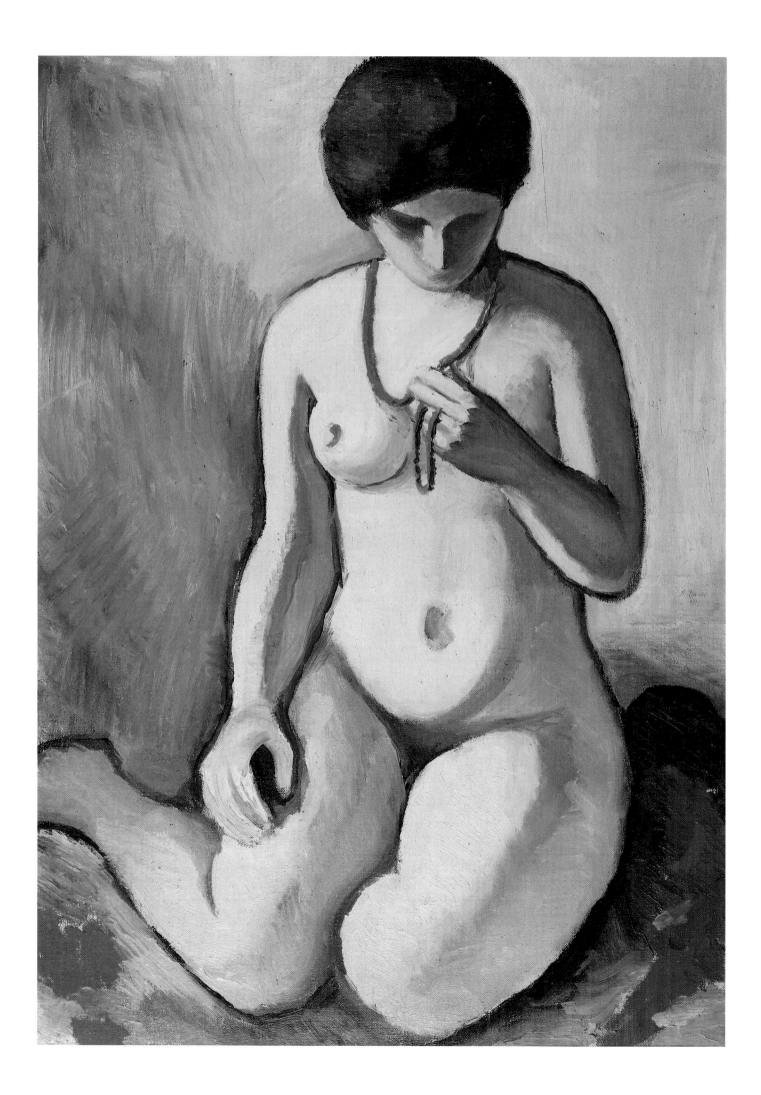

house of the master joiner Staudacher at Tegernsee, surrounded by a blossoming, park-like garden. It was here that the Macke family were staying at the time. A section of the building, projecting at a right angle from its far end, appears, through Macke's emphatic use of colour, to form an unbroken plane with the gable end of this typical Upper Bavarian farmhouse. The composition is dominated by the tree in the foreground and centre of the picture, whose crown forms an arch over the house, and whose branches and foliage intermingle with those of adjacent trees. Macke's depiction of the objects in this picture is simplified, almost diagrammatic; the windows at the gable end are reduced to heavily framed, rectangular areas of light colour. The picture is a clear instance of Macke's tendency to use flat areas as the basic units of pictorial organization; he juxtaposes large, separate areas of paint so that the contrasts between them enhance the individual colours. Here, colour has lost its descriptive function almost entirely, positing instead its own intrinsic, artistic value. Macke achieves a similar virtuosity of colour in his *Garden Picture* (p. 27), painted in Bonn in 1911. His *Tegernsee Landscape with Man Reading and Dog* (p. 33) of 1910, on the other hand, appears to take back this development, using duller colours; although here, too, simplification and a tendency to flat areas of colour determine the character of the picture.

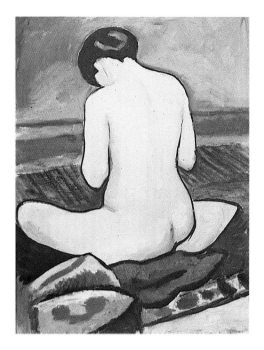

Sitting Nude with Cushions, 1911
Sitzender Akt mit Kissen
Oil on canvas, 54 x 41 cm
Wilhelm-Lehmbruck-Museum, Duisburg

After almost a year of intensive work at Tegernsee, the Mackes decided to return to Bonn. For the town dweller Macke, village life had become too narrow. What is more, he now desired to have a studio of his own. While waiting for their house in the Bornheimer Strasse 88 (today 96) to be completed, they took up residence in the neighbouring house of Elisabeth's parents. The alterations took much longer than planned, so that Macke was unable to move into the rooms of his new atelier and resume work until February 1911.

From the windows which filled three sides of his studio, Macke had a sweeping view over the town, whose neo-gothic St. Mary's church, "surrounded by suburban houses, presented itself daily in a different mood. These motifs turned up in his work over and over again, and he would depict them differently every time", as Elisabeth recounted in her "Recollections".

The picture *St. Mary's in the Snow* (p. 31) was one of the first paintings completed in his new studio in Bonn. In this view of the town, Macke continues to develop the style which had matured during his work at Tegernsee. The picture also betrays Macke's confidence in employing tectonic forms. The houses appear folded like cardboard into clearly defined planes and cubes, forming a dense pictorial arrangement with little spatial depth – not unlike a low relief. The "winter" colours here are not as gay and luminous as usual, but are broken and subdued.

In Bonn, Macke proceeded to paint a series of pictures in the same "Fauvist" vein, including still-lifes, pictures of gardens and landscapes of extreme density and intense colour. His *Vegetable Fields* (p. 26) of 1911 are a particularly striking example. The eye follows a path which forks up from the bottom centre of the painting towards a background of rich yellow hay stacks and violet hills. The individual elements of the painting thus recede in a clearly defined gradation, indicating that Macke

Nude with Coral Necklace, 1910
Akt mit Korallenkette
Oil on canvas, 83 x 60 cm
Sprengel Museum, Hanover

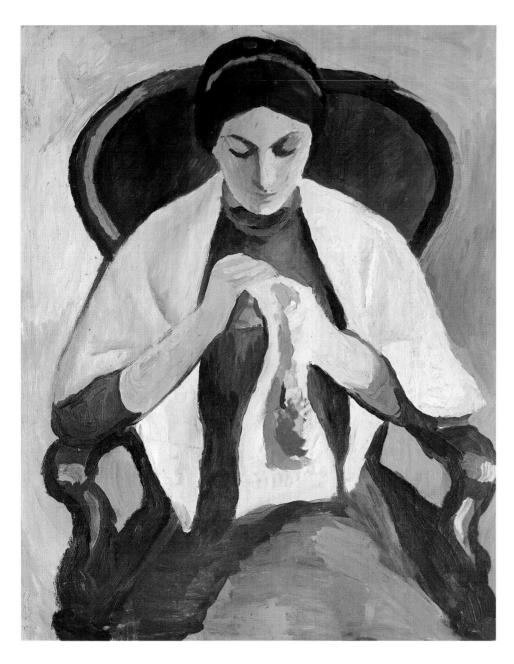

has not dispensed entirely with spatial perspective. Nonetheless, his use
of distance does appear restrained here; detail has lost its significance,
while colour and spatial organisation serve to concentrate the individual
motifs of the picture. One reason for this is Macke's use of thick paint,
whose application with firm, nervous brushstrokes reminds us of van
Gogh's later work. His strong colours, on the other hand, appear to owe
more to Matisse. Liberated of its descriptive function, colour has become
autonomous here; at the same time, its quality is enhanced by the con-
trasts Macke exploits in his use of complementary colours.

The style of Macke's work had begun to change at Tegernsee from Im-
pressionism to Fauvism. Although this process of transformation was
completed at Bonn, Macke's stylistic development did not come to a
standstill. Various new ideas and discoveries, such as Cubism, Orphism
and Futurism, continued to impress Macke and, in rapid succession, to
influence his work. French artists had a particularly lasting effect on his
work; as a Rhinelander, Macke probably felt especially open to their in-
fluence.

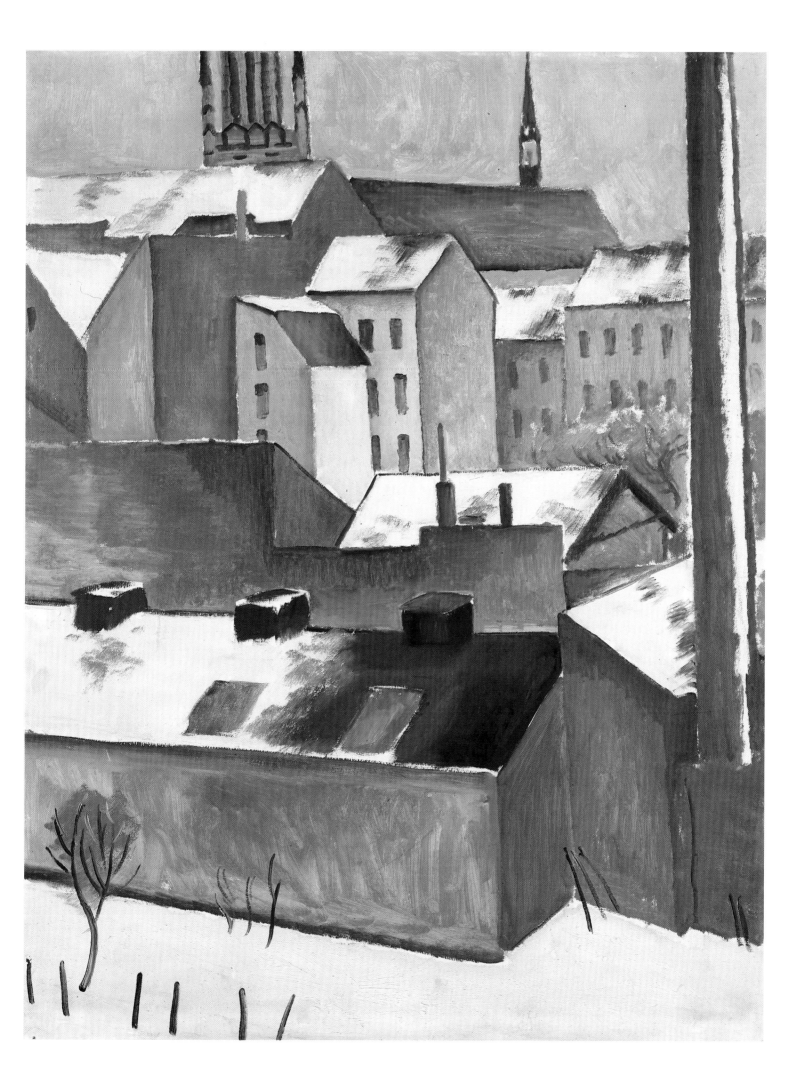

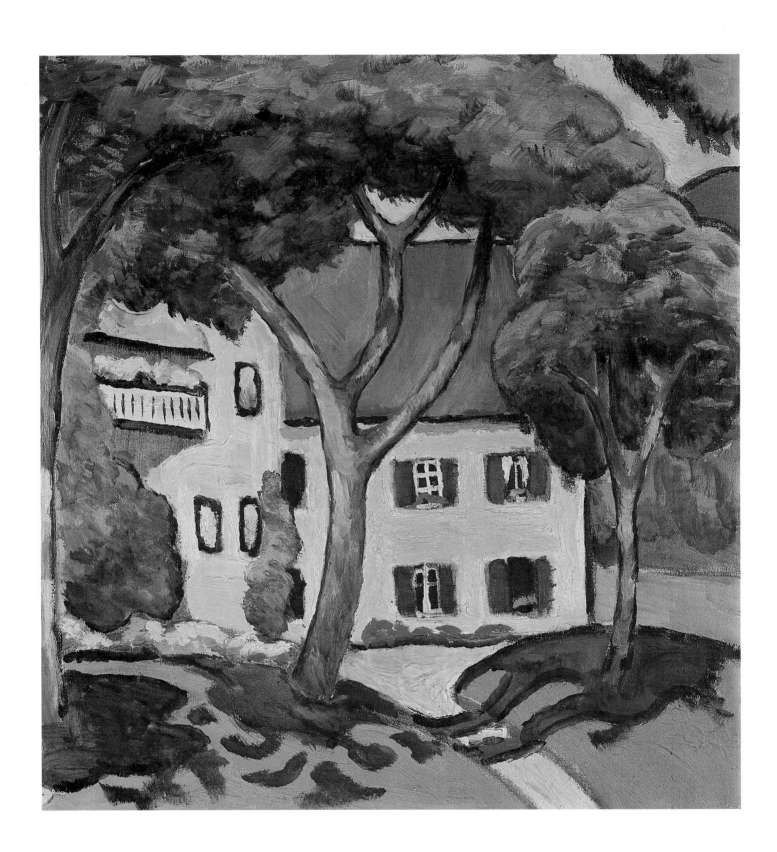

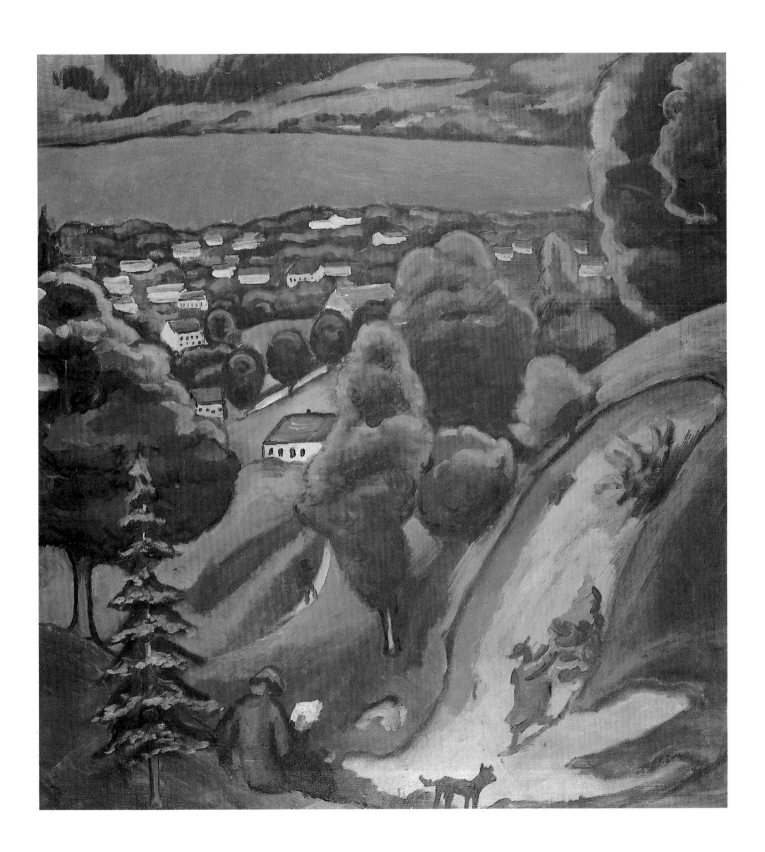

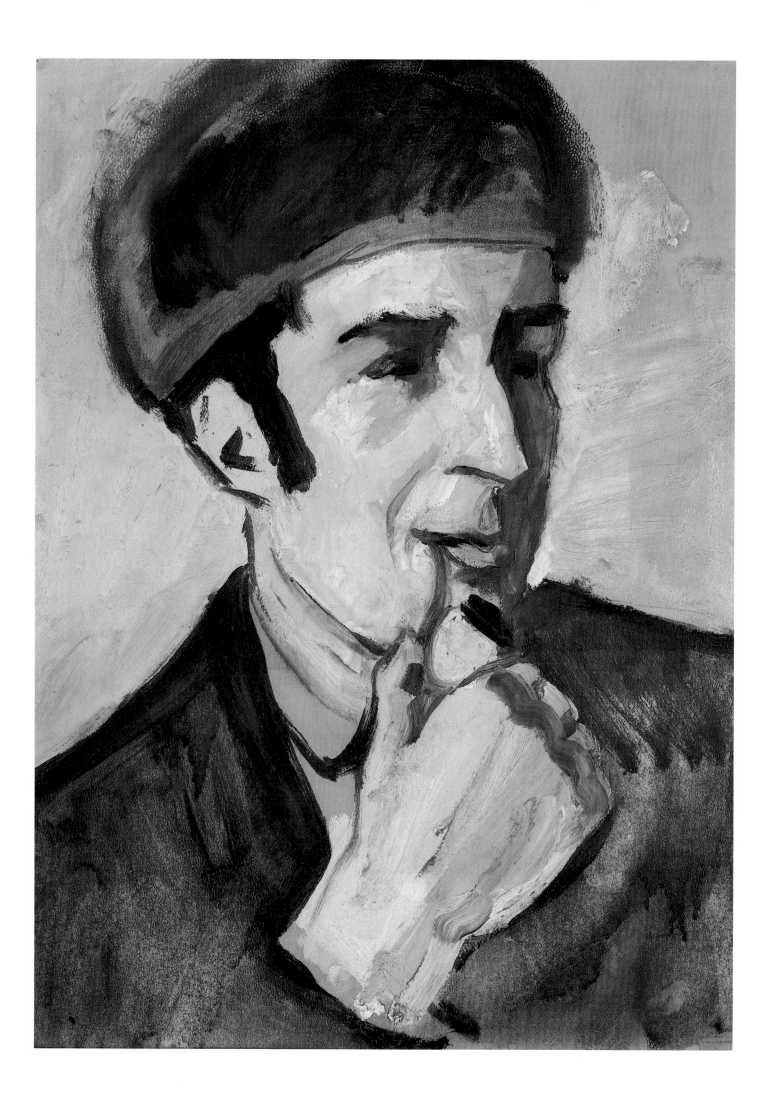

Macke and "Der Blaue Reiter"

In 1911 Macke's artistic development was given new impetus through contact with the artists and ideas of the "Blaue Reiter", and, more especially, through the tensions and vicissitudes of his relationships with Franz Marc and Wassily Kandinsky.

Macke first met Marc after seeing two of his lithographs in the Brakl Gallery at Munich at the beginning of 1910. Although Marc was seven years older than Macke, the latter had known nothing of his work before then. However, Macke now felt he had "discovered" Marc's work, and immediately visited him at his studio. A few weeks later, Marc, accompanied by Maria Franck, met the Mackes at Tegernsee. The two artists soon struck up a warm friendship, which found its expression in their animated correspondence and in a portrait of Marc, painted by Macke in 1910 (p. 34). Marc and Macke had decided to compete at portraying each other. This perhaps explains the rapid, sketch-like style and caricatural mode of expression of this small, but highly personal painting. The portrait is a striking likeness, and shows Marc wearing a fur cap and smoking a pipe. Macke's rapid strokes of thick paint betray the artist's sure hand. The contrast between light and dark, which divides the subject's face sharply into two halves, lends his features their vivid expressiveness.

It was Marc, too, who introduced Macke to an association of artists called the "Neue Künstlervereinigung", Munich, founded in 1909 by Wassily Kandinsky, Gabriele Münter, Alexei von Jawlensky, Marianne von Werefkin, Alexander Kanoldt and others. In February 1911, Marc had become a member of this association and had been immediately elected to its executive board. He now tried to encourage his new friend Macke to become a member of the "Künstlervereinigung", hoping to strengthen the faction around Kandinsky and himself within the association. However, Macke declined this invitation for personal reasons, and also because he had certain practical reservations against the group. He had seen the "Neue Künstlervereinigung" exhibition at the Thannhauser Gallery in Munich in the summer of 1910 – and a second time at Hagen – and had become personally acquainted with most of the artists on this occasion. Although interested in the group and their paintings, his enthusiasm had kept within bounds. Macke remained sceptical, drawing distinctions between the artists and their work, as well as between the individual artists themselves, whose varying artistic merit he was qualified to judge. In any case, he felt unable to identify himself unreservedly with the group, nor could he relate to each of its members equally. Macke's

Franz Marc with "Russi", 1910
Franz Marc mit "Russi"
Copying pencil, 18.8 x 12 cm
Sketchbook No. 7, p. 20
Westfälisches Landesmuseum für Kunst und Kulturgeschichte, Münster

Portrait of Franz Marc, 1910
Bildnis Franz Marc
Oil on pasteboard, 50 x 39 cm
Staatliche Museen Preußischer Kulturbesitz,
Nationalgalerie, Berlin

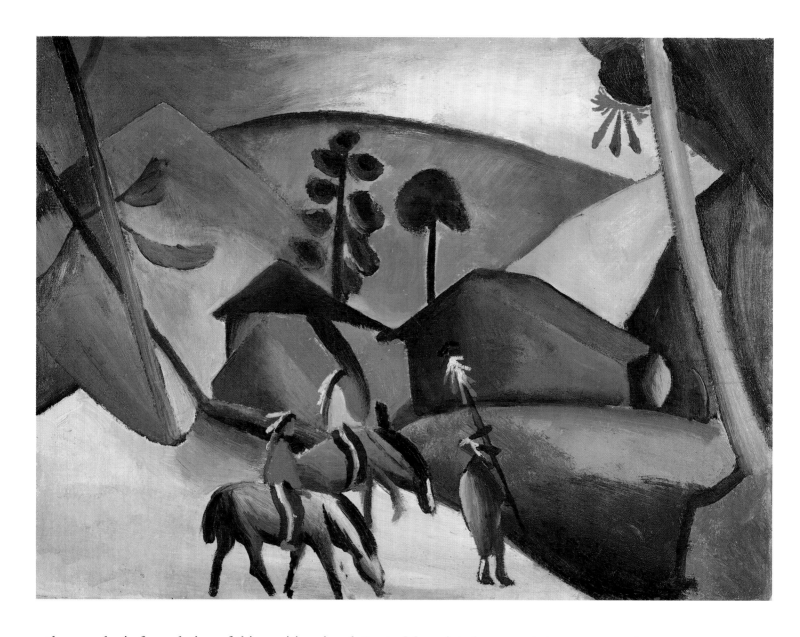

rather emphatic formulation of this position, in a letter to Marc dated
Christmas 1910, is partly unclear, partly contradictory: "The Association
is a very serious matter, and I like its art better than anything else. But,
but – it doesn't really grip me. It interests me a lot. Bossi, Münter and
Kanoldt are perhaps the weakest, and therefore the easiest to take for
granted. Kandinsky, Bechtejeff and Erbslöh have enormous artistic sensi-
bility. But their means of expression are too great for what they are
trying to say. Their voices sound so good, so fine, that what they are ac-
tually saying remains hidden. They thus seem to lack something human.
They wrestle with form far too much, in my view. One can learn much
from what they are trying to do. But Kandinsky's early work, and also
some of Jawlensky, is rather too empty for my liking (. . .)." Although
Macke's opinion of Kandinsky was later to change for the better, a spiri-
tual abyss, ultimately a product of their difference in temperament, but
also of their different attitudes toward art, always remained between
them. Kandinsky's radical "spiritualisation" and "abstraction" could
hardly be combined with Macke's mundane, indeed utterly secular char-
acter; in his pictures, too, the latter was more inclined to empathise with
the material qualities of nature. In a letter sent to Marc in 1911, Macke
went even as far as to disqualify Kandinsky's "intellectual" art – in a

Indians on Horses, 1911
Indianer auf Pferden
Oil on wood, 44 x 60 cm
Städtische Galerie im Lenbachhaus,
Munich

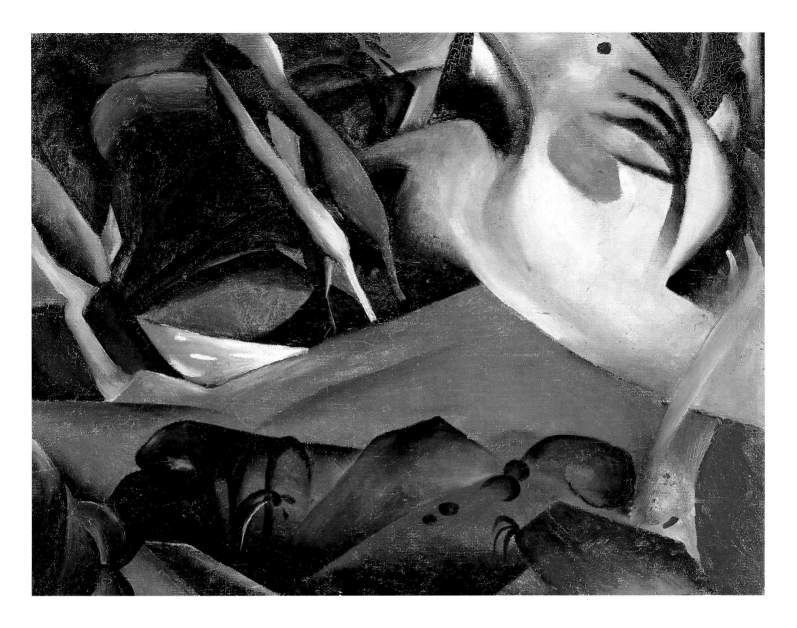

The Storm, 1911
Der Sturm
Oil on Canvas, 84 x 112 cm
Saarland-Museum, Saarbrücken

manner undoubtedly as unclear as it is exaggerated – as pure "decoration", and as "commercial art".

In his refusal to join the new Munich group, Macke seems to have foreseen the difficulties and controversies which were to arise within the Association. At the same time, however, he was to develop a means of fruitful collaboration with Kandinsky and, more especially, with Marc, with whom he maintained a loyal friendship.

"Der Blaue Reiter" emerged from the "Künstlervereinigung", Munich, in 1911. It was not an established, "registered" association with a constitution and "membership", but a loose association of avant-garde artists – some from the "Neue Künstlervereinigung" – whose number was indeterminate, and who had come together at Kandinsky's proposal to plan their own collective publication. "Der Blaue Reiter" was initially no more than the title of this "Almanac", published in book form. Even Macke felt inclined to collaborate on this collection of pictures and essays on contemporary art, literature, theatre and music, whose general theme can be described as the "comparative study of art and art history – of all genres, periods and peoples". In the autumn of 1911, he travelled to meet Marc at Sindelsdorf in Bavaria, and to contribute to the "Almanac", published by Piper in Munich during the following year.

The "Blaue Reiter" was "born during long sessions with debates about art," Elizabeth recalls, "with appeals, with suggestions for prefaces etc. These were unforgettable hours, as each of the men worked over his manuscript, polished it, made last changes (. . .)". Macke selected the pictures for the ethnographical section of the book and contributed an essay on "Masks", which, using highly expressive language, compared primitive art with modern art in Europe, showing how these were connected.

In December 1911, after irreconcilable differences of opinion with the jury selecting work for a group exhibition of the "Neue "Künstlervereinigung", Kandinsky and Marc left the Munich association. With all haste, they proceeded to organise their own exhibition, which, under the heading "Der Blaue Reiter", was also shown at the Thannhauser Gallery in Munich in December 1911. The "Blaue Reiter" thus made its inaugural appearance as a group of artists, and as an exhibition cooperative. Once again, Kandinsky was its driving force and intellectual motor.

Although he had contributed three of his own pictures (*Indians on Horses,* p. 36; *Storm,* p. 37; *Still-Life with Agave*), Macke did not see this first "Blaue Reiter" exhibition until January 1912, when he himself organised its second showing at the "Gereon Club" in Cologne. A letter to Marc betrays considerable reservations against the content of the exhibition, an aloofness which seems partly to derive from wounded vanity on Macke's part: "I went to the "Blaue Reiter" exhibition on Saturday and Sunday. There was a very interesting crowd of people there again, and there was much discussion of the paintings. Rousseau, Delaunay, Epstein, Kahler, Kandinsky, Campendonk and some of Burliuk interested me most. I felt pretty disappointed by your things. It all seemed so unfinished to me, so deliberate, and yet so short of the mark. I have just been thinking that the "Blaue Reiter" does not really represent my work. I have always been convinced that other things of mine are more important. But it won't be easy now to get me to hand them over. On the other hand, I do feel it necessary to say that I like *Woman Playing a Lute,* which was not sent here with the exhibition, far better than much of what is actually being shown. Narcissism, fake heroism and blindness have a lot to answer for in the "Blaue Reiter". All those high-sounding words about the birth of a great spiritual moment still resound in my ears. Kandinsky can air his personal opinion about that or any other revolution he cares to mention. But I dislike the whole thing, especially after this exhibition. Take my advice – work, and don't spend so much time thinking about blue riders or blue horses. (. . .) In my opinion, art does not come from the will, nor, as Schönberg says, does it come from necessity; it comes from ability. (. . .)"

Despite the animosities which had resumed between Macke and the artists of the "Blaue Reiter", and in particular his reservations against Kandinsky, Macke also participated with sixteen drawings in the group's second exhibition. This had already opened in February 1912 at the gallery of the Munich art dealer Goltz, under the heading "Black and White". As its title suggests, the exhibition was dedicated exclusively to the graphic arts.

The "Blaue Reiter" was not to engage in any further collective activity – beyond the exhibitions which toured various towns until 1913. It re-

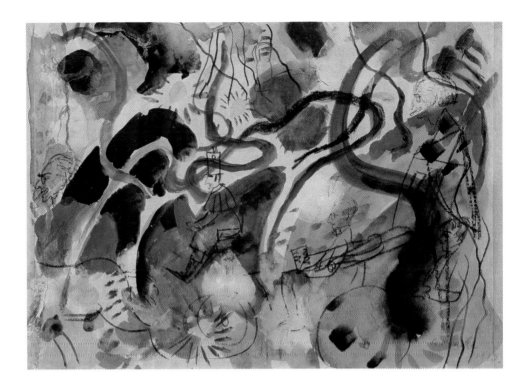

Persiflage on the "Blaue Reiter", 1913
Persiflage auf den Blauen Reiter
Water-colour, pencil, black crayon,
24.6 x 34.5 cm
Städtische Galerie im Lenbachhaus,
Munich

mained, therefore, a short, but significant episode in the history of modern art prior to the First World War. Macke's own intermezzo with the "Blaue Reiter" had lasted just under a year, ending in February 1912. He literally drew a line under this chapter of his life by caricaturing "Der Blaue Reiter", and especially Kandinsky, in a pastiche in 1913 (p. 39) of the water-colour style of Kandinsky's first abstract pictures. In the bottom right corner of his biting persiflage, Macke himself is seen observing this "nightmare", in which – along with portraits of Kandinsky and Marc – Herwarth Walden appears in the form of two, over-sized figures framing the picture on the left and right. Walden had taken the "Blaue Reiter" artists under his wing, exhibiting and "marketing" their work in his Berlin gallery "Der Sturm".

While the theoretical antagonisms between Macke and Kandinsky seemed almost to be unreconcilable, Macke and Marc settled their differences during the summer of 1912 and finally sealed their personal friendship by collaborating over a painting – just as Macke's portrait of Marc had also marked the beginning of their friendship. In October 1912 they painted a "Paradise" fresco in Macke's studio in Bonn – a mural with animals (by Marc) and human figures (Macke's Adam and Eve) in a landscape. Although this had been conceived as a common project, Marcian elements tend to dominate the painting.

The artistic interchange between Macke and the painters of the "Blaue Reiter" was of short duration, and was also much less intense than is usually supposed. Marc's internalised "searching and wrestling for forms of expression which do not lie in appearances themselves, but which make use of appearances to express what lies behind them", and also the intellectual "spirituality" of Kandinsky contradicted Macke's view that painting had its origins in the observation of things themselves.

Only a small number of Macke's paintings betray the direct influence of the "Blaue Reiter": they occupy a special position within his oeuvre.

Indians on Horses (p. 36) was completed in the summer of 1911, probably during one of Marc's visits to Bonn. At the time, Macke had been using the Indian-motif in his paintings and drawings in various ways, inspired perhaps by Gauguin, or possibly by having read Karl May's adventure stories. The mountainous landscape is composed of large planes and cubes of strong colour, modelled in slightly broken, clayey paint. The trunks of several trees form a rhythmic interruption of the curved mountain ridges. The centre of the picture is occupied by a cube-shaped, angular group of houses. In the foreground, two Indians in feather head-dress sit astride grazing horses. A third, on foot, heads the group carrying a spear decorated with feathers. The cube-shaped, and yet soft, organic forms, the fusion of colours and the contrasts of light and dark are reminiscent of the animal pictures and landscapes of Marc during those years, particularly in the way the different luminous complementary colours blend into one another, or appear to emerge from one another. The theme of the picture, Indians, is entirely subordinate to its form; indeed, far more so than is the case even in Marc's own work, the theme has become little more than an excuse for form. The serene, relaxed atmosphere of the painting is generated by the concentration of its colours. One senses Marc's influence here – perhaps more so than in any other picture by Macke.

The Storm (p. 37) was also painted in 1911 – in Marc's studio at Sindelsdorf during work for the "Blaue Reiter" Almanac in October. It thus was painted in the company of Marc and Kandinsky, and was the product of intense discussion with both of them. *The Storm* is one of Macke's most "abstract" paintings – a turbulent and eerily lit landscape, apparently during, or immediately after, a violent and atmospherically cathartic storm. The forms and colours seem full of curious and paradoxical contradictions. The radiant intensity of the red appears to describe a steeply rising, pointed mountain, and yet the colour glows with an almost immaterial translucency. By contrast, the livid, pale yellow light-phenomenon in the sky looks like a leaping animal, or appears at least to be materially substantial and dense. These contradictions lend the painting an almost ghostly sense of unreality, as if part of a fairy-tale.

The identical date of origin of *The Storm* and Marc's *Yellow Cow* has often led to the comparison of these paintings, and to an attempt to prove Marc's influence upon Macke. The comparison is superficial, however, and fails to convince. There may be a far deeper kinship with Marc's *Deer in the Forest*, a painting completed in the same period, which shows a similar degree of abstraction, and also a form-colour relationship comparable to that of Macke's *Storm*. It is interesting to note that Marc's picture was shown with Macke's *Storm* - and with the *Indians* - at the first "Blaue Reiter" exhibition, and that it was also reproduced in the "Almanac".

The comparison often made with Kandinsky's *Cow* of 1910 is equally unconvincing. At most, the two pictures are related through their large format. Kandinsky's picture takes its bearings more from real objects, whereas these seem to have been almost entirely eliminated from Macke's painting, and to have been replaced by an abstract composition. Macke's *Storm* thus appears indebted to Kandinsky in a general sense, al-

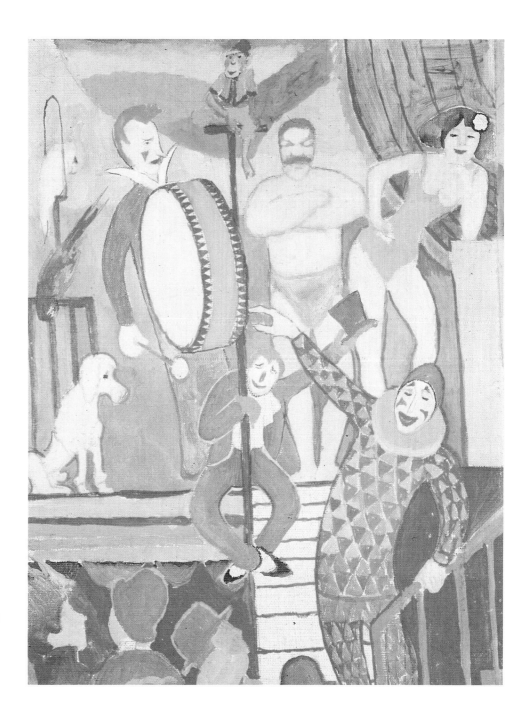

Circus Picture II: Pair of Athletes, Clown and Monkey, 1911
Cirkusbild II: Athletenpaar, Clown und Affe
Oil on canvas, 54 x 39.5 cm
Private collection, Berlin

though not specifically to his *Cow* - even if Macke, according to his own testimony, was directly confronted with this painting during his work at Sindelsdorf.

The "Blaue Reiter" remained but a brief episode in Macke's life and work; even the mutual exchange of ideas and influence was a peripheral matter of short duration. Nonetheless, it did result in a lasting friendship with Marc. Other influences, which Macke considered more important, were soon to push the "Blaue Reiter" out of Macke's mind. In 1913, he was to note in retrospect: "My position as a painter is that Kandinsky has passed away peacefully because Delaunay has set up shop next door to him, and because you could really see in him what living colour was, as opposed to an incredibly complicated, and yet absolutely shallow composition based on dashes of colour. It makes one want to cry when one's hopes are dashed. But then Delaunay began with his spatial Eiffel Tower, and Kandinsky with ginger-bread."

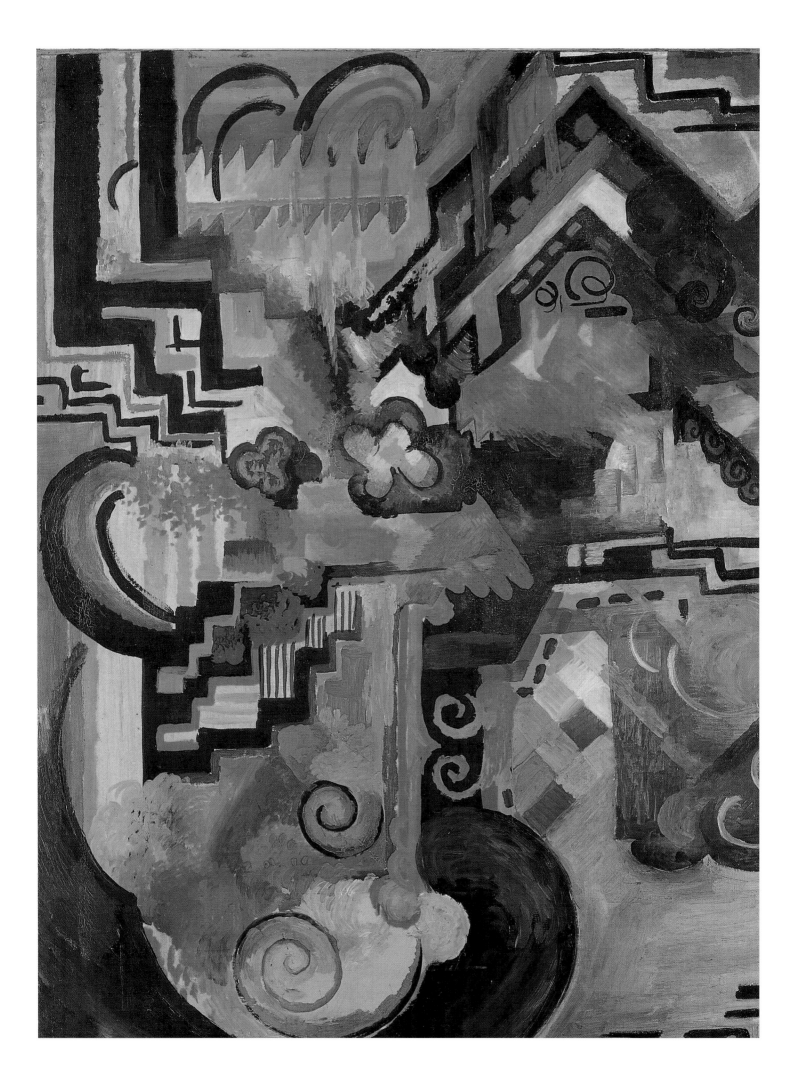

Between "Abstraction and Empathy"

If Macke's work in 1911/1912 and at the beginning of the following year was shaped by his reception of Fauvism, other artistic problems and styles were to occupy him from 1913. This latest turn in Macke's continuing development and search for his own artistic vocabulary was a reaction to the constantly changing impressions he received from his contemporary cultural environment. It also resulted from his personal discovery of new models in recent avant-garde art, as well as being a consequence of theoretical influence and insight. The erratic development of the various trends in modern art which followed one another in rapid succession shortly before the First World War, in any case, makes it impossible to decide where certain innovations or ideas originated. It was a development generated within a dense, international network of artistic exchanges.

"Abstract art" started almost simultaneously in Germany, France, Holland and Russia, shortly after Cubism had been "invented" in France, and Futurism in Italy. Meanwhile, French Fauvism and German Expressionism, themselves still very recent avant-gardes, could hardly be considered outdated; even Impressionism had not been forgotten – indeed, it now gained in popularity, enjoying almost universal recognition.

In 1908 Wilhelm Worringer's epoch-making dissertation "Abstraction and Empathy" appeared, anticipating the course of future abstract art, or at least paving the way for it theoretically. His interpretations and analyses of already existing tendencies to abstraction had a catalysing effect on many young artists.

There were a number of points of contact – some personal – between Macke and the art historian Worringer: Worringer's mother ran the high-class restaurant in the Zoological Gardens in Cologne, which Macke liked to visit from Bonn with his sketch-books, and where he would often paint. His well-known "zoo-pictures" were painted, or at least inspired, here. Worringer's sister Emmy was a painter, and, like her brother Adolf, maintained a close friendship with the Mackes. Worringer himself was older than the others. The inspiration for his dissertation had come not least from his direct contacts with young avant-garde artists, whom he was to influence in turn. There is evidence to show that Macke, too, read Worringer's publication around 1912 and – it appears – drew consequences from it for his own work.

Worringer's treatise was partly programmatic, and partly an expression of the prevailing *Zeitgeist*. It posited two, fundamentally opposed

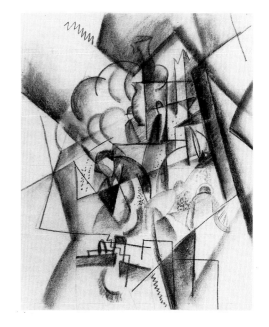

Cubist Divison of Space with Figures, 1913
Kubistisch aufgeteilter Raum mit Figuren
Crayon on cardboard, 32 x 26.8 cm
Kunstmuseum, Düsseldorf

ILLUSTRATION PAGE 42:
Coloured Composition (Hommage à Johann Sebastian Bach), 1912
Farbige Komposition (Hommage à Johann Sebastian Bach)
Oil on cardboard, 101 x 82 cm
Wilhelm-Hack-Museum, Ludwigshafen

ILLUSTRATION PAGE 44:
Coloured Forms II, 1913
Farbige Formen II
Oil on cardboard, 36 x 31 cm
Wilhelm-Hack-Museum, Ludwigshafen

ILLUSTRATION PAGE 45:
Coloured Forms I, 1913
Farbige Formen I
Oil on pasteboard, mounted on wood,
53.1 x 38.5 cm
Westfälisches Landesmuseum für Kunst und Kulturgeschichte, Münster
Permanent loan from private collection

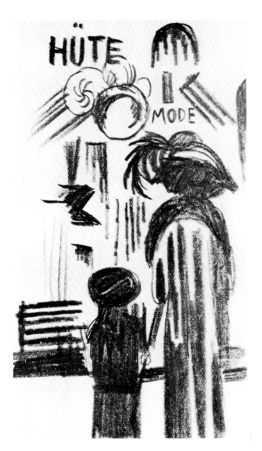

Hats-Fashion, 1913
Hüte-Mode
Sketchbook No. 55 b, p. 28
Pencil on paper, 13.5 x 7.7 cm
Westfälisches Landesmuseum für Kunst und
Kulturgeschichte, Münster

Large Bright Shop Window, 1912
Großes helles Schaufenster
Oil on canvas, 106.8 x 82.8 cm
Sprengel Museum, Hanover

poles of art: "abstraction", as a non-figurative invention, a principle of order, a formal structure; and "empathy" as the mimetic representation of external reality. Worringer saw abstraction as existing prior to the "invention" of so-called "abstract art" – in the purely decorative, and often geometrical, non-representational art common to all times and all peoples. However, he also saw all art as equally pervaded by both principles – abstraction and empathy. The difference between styles could be defined by the position each art occupied between these two poles, that is to say, by its degree of abstraction, or "stylisation". According to Worringer, all art is therefore "abstract"; abstraction is a latent tendency in all art – a fundamental principle of all artistic behaviour.

Worringer's dissertation had a direct influence on the various versions of Macke's *Colour Compositions* and *Colour Forms* of 1912 and 1913. His few totally abstract pictures are based on abstract ornamental textile designs, though without representation, or even a suggestion, of the latter's objective quality. In 1912 and 1913, Macke also painted several designs for embroidery and carpet weaving by taking decorative abstraction which originally had been inspired by textiles, and making it re-available for use in textiles themselves. Macke's formal obligation to ornamental textile design is shown particularly clearly in his *Coloured Composition (Hommage à Johann Sebastian Bach)* (p. 42) of 1912, which also contains analogies to abstraction in musical composition. It is also possible to compare these works with paintings completed in 1910/1911 in Paris by the Czech artist Frank Kupka. Macke may have seen these during his visit to Paris. Besides Kandinsky's first attempts at abstract art, Kupka's paintings were among the very first non-representational pictures of the modern era.

Even in 1907, while still deeply affected by his discovery of Impressionism, Macke had expressed his theoretical tendency to abstraction in terms of synaesthetic references to music. "My entire joy in life," he wrote, "comes almost entirely from pure colour. Last week I tried to combine colours on a board while keeping my mind free of objects like human figures or trees – as if I were embroidering a pattern. The things that give music its mysterious beauty also fascinate us in painting. But it would require an inhuman degree of effort to organise colour within a system similar to that of musical notes. Colours, like music, have their counterpoint, their treble and bass clefs, their flats and sharps. An infinitely fine sense of colour can establish this order without the least knowledge of all this."

Before painting his first purely abstract, utterly non-representational pictures, Macke had approached abstraction step by step through experience of it in his own painting. Fauvism had contained a powerful element of abstraction in its simplified forms and free use of unbroken colours, both of which were only vaguely based on, or influenced by, the observation of nature. The Fauvists' use of strident colours, especially, was "abstract".

The Cubists' break with illusionism was even more radical. The early, Analytic Cubism, in particular, had abstracted its objects to fragmentary crystals and finely angled, faceted reliefs within shallow, non-perspectival picture spaces, breaking down three-dimensional, concrete structures

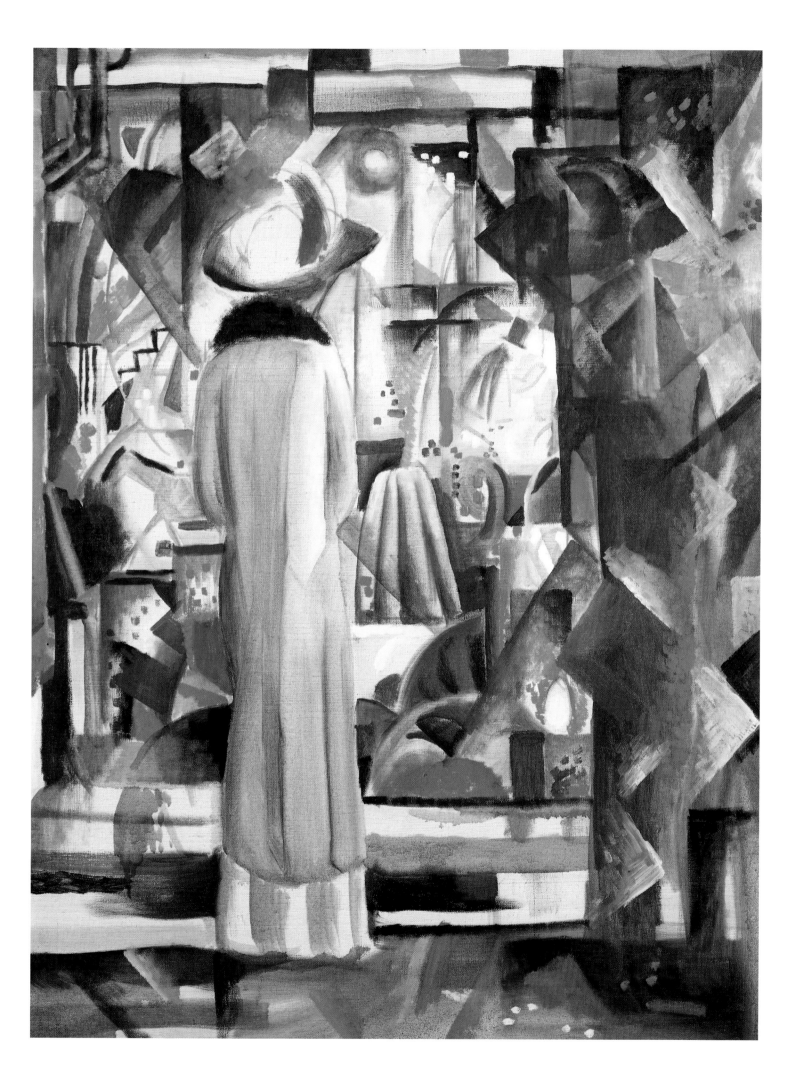

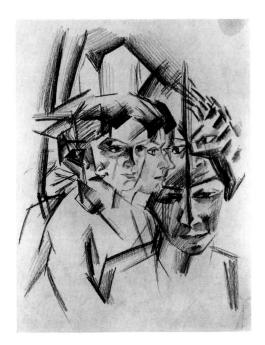

Futurist Heads (Elisabeth), 1913
Futuristische Köpfe (Elisabeth)
Pencil, 28.5 x 21.6 cm
Kunsthalle, Bremen

into flat planes and showing many aspects of the same object simultaneously. Futurism, which had profited from Cubist ideas on painting, was equally severe in breaking with centralised perspective, extending the traditionally static, untroubled, and quiet medium of the panel painting to include the dimensions of time, dynamism and acoustics. *The Noise of the Street Penetrates the House* (p. 52) of 1911, is the apt title of one of the most important paintings of the leading Italian Futurist Umberto Boccioni. Thus Futurism, too, was based on abstraction from the known, visible world, on the structure of thought, on premises derived from the modern natural sciences. For the sciences, too, had begun to demonstrate the existence of elements and components of nature which could not be experienced through the senses, but could only be measured by abstract means; they were therefore turning nature into something "calculable".

Orphism, a term coined by Guillaume Apollinaire to describe a style developed by Delaunay, also involved a resolute abstraction from the visible world, and an extension of the optical to include simultaneous sense impressions. Delaunay had injected a richer, more lyrical attitude towards colour into the Analytical Cubism of Picasso and Braque, and into Italian Futurism, using certain methods of colour contrast, and ideas derived from the physics of light and colour, to define the basic principles of formal composition.

There is no reliable evidence to suggest when Macke first saw Cubist pictures. There is no account of this in connection with his first sojourn in Paris in 1907. After all, it was only during that year that Picasso had begun his Cubist experiments. Macke probably did not see his first examples of Cubist art until 1910, at the second exhibition of the "Neue Künstlervereinigung", Munich. Cubism had very little influence on his work before 1912, however. In that year, Picasso's *Woman with Guitar at a Piano* (1911) had been reproduced in the "Almanac" of the "Blaue Reiter". This painting evidently made a strong impression on Macke and inspired him to several drawings, entitled *Abstract Forms II*, and *Cubist Division of Space with Figures* (p. 43), both completed in 1913. In both these drawings, comparable in format and size to the reproduction of Picasso's painting, Macke varies Picasso's netlike structure of diagonal planes and lines. This geometrical grid is interspersed with crystalline fragments of objective reality, which are stylised beyond recognition, mounted rigidly within the abstract composition and set between non-spatial strata.

However, Analytical Cubism was to remain a brief episode in Macke's development, much as Macke confessed to his admiration of Picasso.

Futurism, on the other hand, itself influenced by Cubism, made a deeper and more complex impression on Macke's work. Macke first became acquainted with Futurist pictures in 1912, a highly eventful and artistically formative year for Macke. Filippo Tommaso Marinetti's "Futurist Manifesto" had been published in the Parisian newspaper "LE FIGARO" in 1909, and Macke will almost certainly have known it; however, he is unlikely to have come across works by Futurists before 1912. In the autumn of that year, a "Futurists" exhibition which was touring Eu-

Bright Women in front of the Hat Shop, 1913
Helle Frauen vor dem Hutladen
Oil on canvas, 110 x 76.5 cm
Karl Ernst Osthaus Museum, Hagen

rope was also shown at Otto Feldmann's "Rheinische Kunstsalon" in Cologne, sending Macke, and many of his contemporaries who were also open to the ideas of modernism, into raptures. The enthusiastic reception enjoyed by Futurism probably derived from its refusal to limit itself to formal and analytical abstraction in the manner of French Cubism; instead, it placed new forms in the service of new subjects. Futurism presented itself as a vital and highly dynamic movement, whose energy came from its tempestuous and optimistic belief in the future, its willingness to launch itself into the twentieth century.

Many of Macke's pictures reveal the direct influence of Futurism, as well as traces of Macke's critical engagement with it, especially those

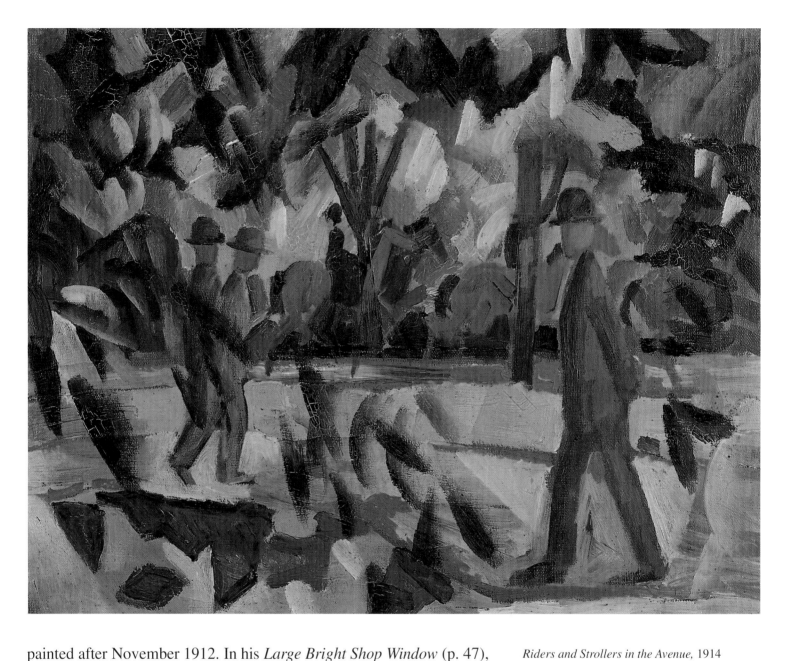

painted after November 1912. In his *Large Bright Shop Window* (p. 47),
in particular, the echo of Boccioni's *The Noise of the Street Penetrates
the House* (p. 52), which Macke had seen in Cologne a few weeks – per-
haps only a few days – before, is undeniable. The first in a series of
"Shop Window" pictures which Macke later continued at Hilterfingen,
this painting also introduced a new iconography. Boccioni's influence is
unmistakable. However, whereas life in Boccioni's painting is loud and
prosaic, bursting forth dynamically in the form of a building site bustling
with workers, in Macke, it is brought to rest in a shop window display –
a gay, artistically arranged still-life of purchasable goods. Macke's re-
sponse – both in an optical and metaphorical sense – to the violent, pro-
ductive activity enacted in Boccioni's picture, is contemplative.

In 1913, Macke painted *Bright Women in front of the Hat Shop* (p.
49). The figures in the foreground are interlocked with awnings, church
towers, a tram, and sections of facades from the narrow street in the
background, forming a complex, and complicated, pictorial unity. The
stylised, Futurist abstraction absorbs the depicted objects almost entirely,
making them appear as parts within a synaesthetic totality of figures and
forms, rapid movements and piercing sounds.

Riders and Strollers in the Avenue, 1914
Reiter und Spaziergänger in der Allee
Oil on canvas, 47 x 59.5 cm
Museum am Ostwall, Dortmund

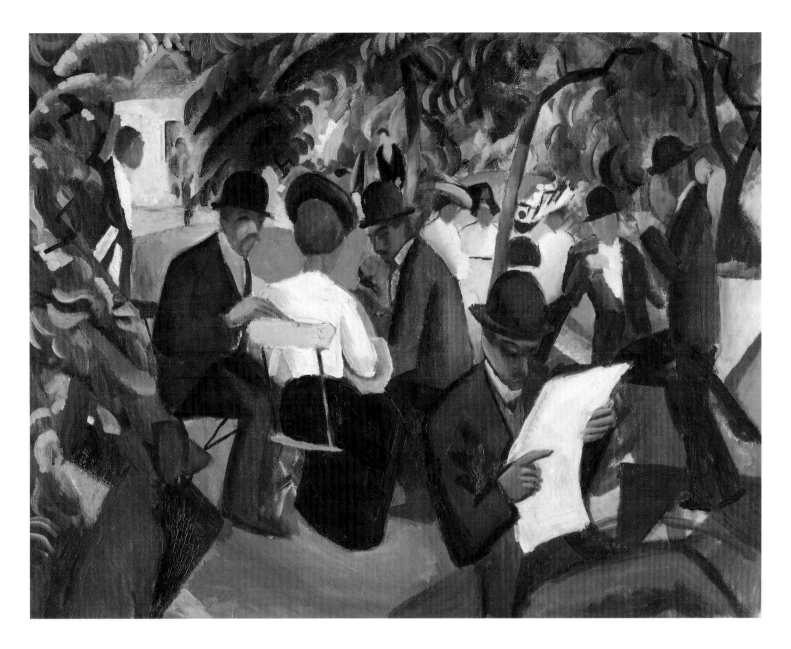

But Macke also "stylised" other subjects in the Futurist manner: *Girls Bathing with Town in Background* (p. 53), for example, also painted in 1913. This traditional motif – three nude girls and a clothed figure with her back turned to us – is anything but a loud, urban scene; instead, it depicts a peaceful idyll, a bathing scene in natural surroundings. The light is refracted into a myriad of scintillating components; the crystalline colouring lends an almost electric quality to the summer heat. The complicated abstract stylisation demands the full attention of our senses as well as our intellect, subordinating the objective corporeality of the figures entirely to the ordering principle of the painting.

Whereas the influence of Cubism is still felt in the painting *Strollers by the Lake I* (1912), Macke's awakening interest in Futurism can already be observed in *Garden Restaurant* (p. 51), painted in the same year. A comparison of these two paintings reveals the fluidity of Macke's transition from Cubism to Futurism, and how inseperably linked these styles were within Macke's own adaptation of them. The interrelationship between Cubism and Futurism in Macke's thought and understanding of art is further exemplified in the drawing *Futurist Heads* (p. 48) of 1913, a multi-faceted projection of his wife's head portrayed in

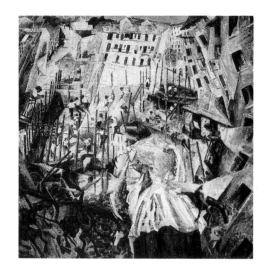

Umberto Boccioni:
The Noise of the Street Penetrates the House,
1911
La strada entra nella casa
Oil on canvas, 100 x 100 cm
Sprengel Museum, Hanover

Girls Bathing with Town in Background, 1913
Badende Mädchen mit Stadt im Hintergrund
Oil on canvas, 100.6 x 80.4 cm
Bayerische Staatsgemäldesammlungen, Staats-
galerie moderner Kunst, Munich

Cubo-Futurist refraction, as it were. Elizabeth's head is shown from dif-
ferent aspects, shifting rhythmically through the six phases of a move-
ment from profile to frontal view. Her easily recognisable features are
locked within an abstract, structural grid. This small format drawing
could almost be described as a methodic exercise in Cubist-Futurist styli-
sation.

A freer handling of elements of Futurist dynamics can be observed in
paintings Macke completed during the last year of his life. In his Dort-
mund picture *Riders and Strollers in the Avenue* (p. 50) of 1914, we reco-
gnise several figures on horseback riding along the horizontal plane
which divides the painting roughly into two halves; they are moving
from left to right: two on the left, slightly staggered, walking; then, fur-
ther right, trotting; and one, at the far right, leading at a gallop. The
vague sketchiness of the riders is reminiscent of studies of motion as a
process broken down into its various phases, such as those recorded in
the photographic stills and picture sequences of Edward Muybridge or
Etienne Marey in the last decade of the nineteenth century – studies
which influenced painting, especially Futurism. Franz Kupka based his
studies of figures on horseback, which date from as early as 1901/2, on
this "chronography", thus anticipating Futurist elements of movement.
Macke may also have been indirectly influenced by these studies.

The art and personality of Robert Delaunay made a lasting impression
on Macke. According to Macke, meeting Delaunay and seeing his paint-
ings were "like a revelation". Macke had first seen pictures by Delaunay
at the first "Blaue Reiter" exhibition in 1912. An "Eiffel Tower", which
Macke's patron and uncle-in-law Berhard Koehler had bought for his col-
lection, was also reproduced in the "Almanac". Macke may also have
met Delaunay during his fourth stay in Paris, in the autumn of 1912. In
March 1913 a Delaunay exhibition, which had been to Herwarth
Walden's Berlin gallery "Der Sturm", was shown in the "Gereon Club"
in Cologne. In January, Delaunay and his friend and interpreter Guil-
laume Apollinaire came to Cologne, making use of the opportunity to
visit Macke in Bonn.

Among the twenty-one pictures shown at the Cologne exhibition,
there were eleven from Delaunay's series of "Fenêtres" – the so-called
"Window-pictures", begun in 1912. These new works by Delaunay made
a greater impression on Macke than any other work of art had ever done.
Delaunay's "Orphism", or "Simultanism", was a colouristic extension of
Cubism and Futurism. Macke had already been affected by these move-
ments, but he was now encountering them refracted onto a more refined
plane, so to speak – through the prism of Delaunay's idiosyncratic lens.
The quality which distinguished Delaunay from the Cubists fundamen-
tally, however, was his exuberant and luminous colouring. Colour was
the basic inspiration for his painting, combined initially with Cubist and
Futurist forms. However, he soon outgrew the latter, combining colour
with geometric shapes, especially circles, and painting genuine abstracts.

With Worringer's ideas in his mind, and with the model of Delaunay's
"Fenêtres" before his eyes, Macke went on to create complex paintings
in which visual empathy and imaginative abstraction were finely bal-
anced. Just as Delaunay had seen the world virtually through the "pic-

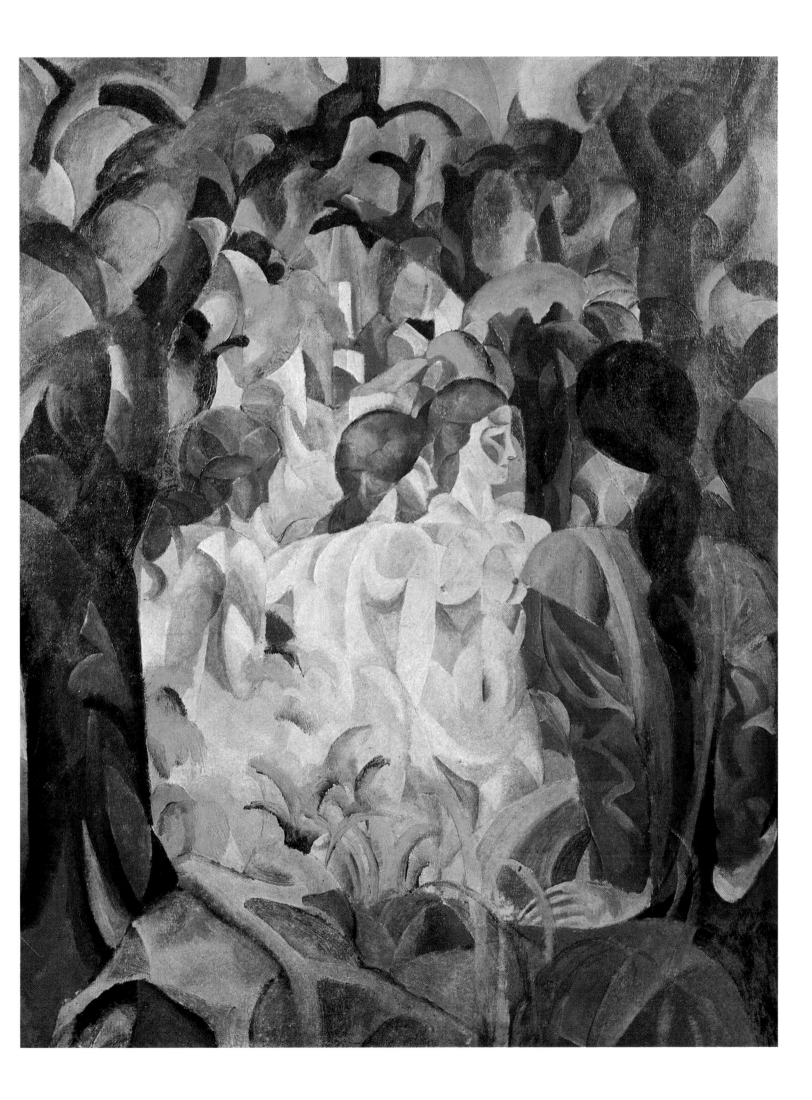

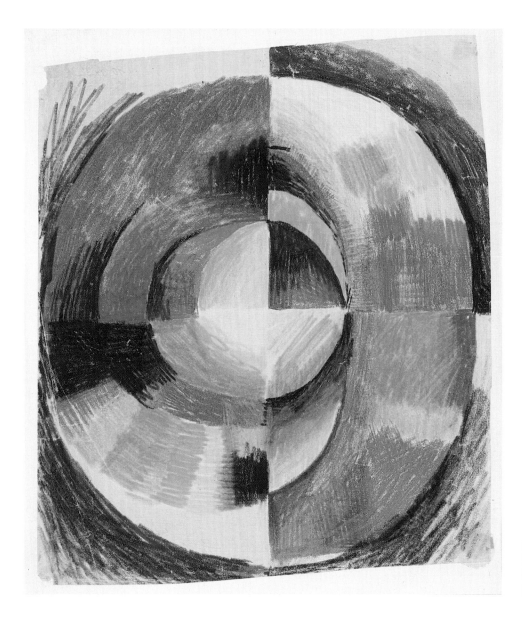

Colour Circle II (large), 1913
Farbenkreis II (groß)
Coloured crayons, 27.3 x 24.3 cm
Städtisches Kunstmuseum, Bonn

ture" frame of his window, so Macke, too, fused vision and reality in his
highly compressed pictures. The nearest Macke came to Delaunay –
something between a consciously imitative study and the unconscious in-
vention of a kindred spirit – were his "small" and "large" *Colour Circle
II* (p. 54) of 1913, which were influenced directly by Delaunay's *Circu-
lar Forms* and *Suns* of the same year, while these, in turn, appear related
to Kupka's *Discs* of 1911/12. In Macke's and Delaunay's pictures, con-
centric circles surrounding a prismatically refracted, brightly coloured
nucleus, form zones or spheres of glowing colour, like the projection of
a chromatic spectrum, and are divided into segments by a "hairline
cross" of verticle and horizontal lines. Both pictures are as abstract in
their effect as scientific illustrations of the origin and composition of col-
ours, and as poetic as dramatic accounts of the birth of colours from the
pure white of light.

At the same time, Macke achieves more depth and a greater degree of
transcendence in his crayon drawings than Delaunay, whose tendency is
more persistently decorative. Macke thus rises above any suspicion of
plagiarism, and justifies his proximity to Delaunay in terms of his own,
independent, further development.

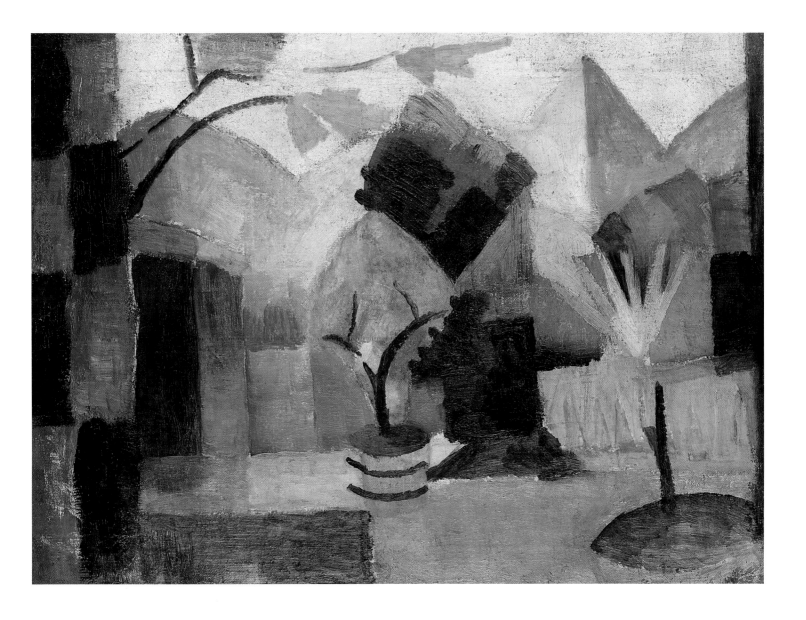

His wonderfully mellow, and finely balanced *Garden on Lake of Thun* (p. 55) of 1913 is another example of Macke's free handling of the late echoes of Cubism and Futurism. In form and colouring, the picture demonstrates an apparently natural harmony between "empathy" and "abstraction", representation and free form. This work is usually seen as dating from 1913. However, it was probably completed after Macke's journey to Tunisia. Its cube-shaped, angular planes, and the crystalline clarity of the colours and light, are unthinkable without Macke's experiences in Tunis, and his knowledge of contemporary paintings by Paul Klee.

Macke admired the work of his modern contemporaries, letting it fascinate and stimulate him, without giving up his own independence. In open, uninhibited dialogue with the art of his time, Macke grappled with the problems of visual empathy and imaginative abstraction – to arrive at his own, unmistakable, and highly personal style.

Garden on Lake of Thun, 1913
Garten am Thuner See
Oil on canvas, 49 x 65 cm
Städtisches Kunstmuseum, Bonn

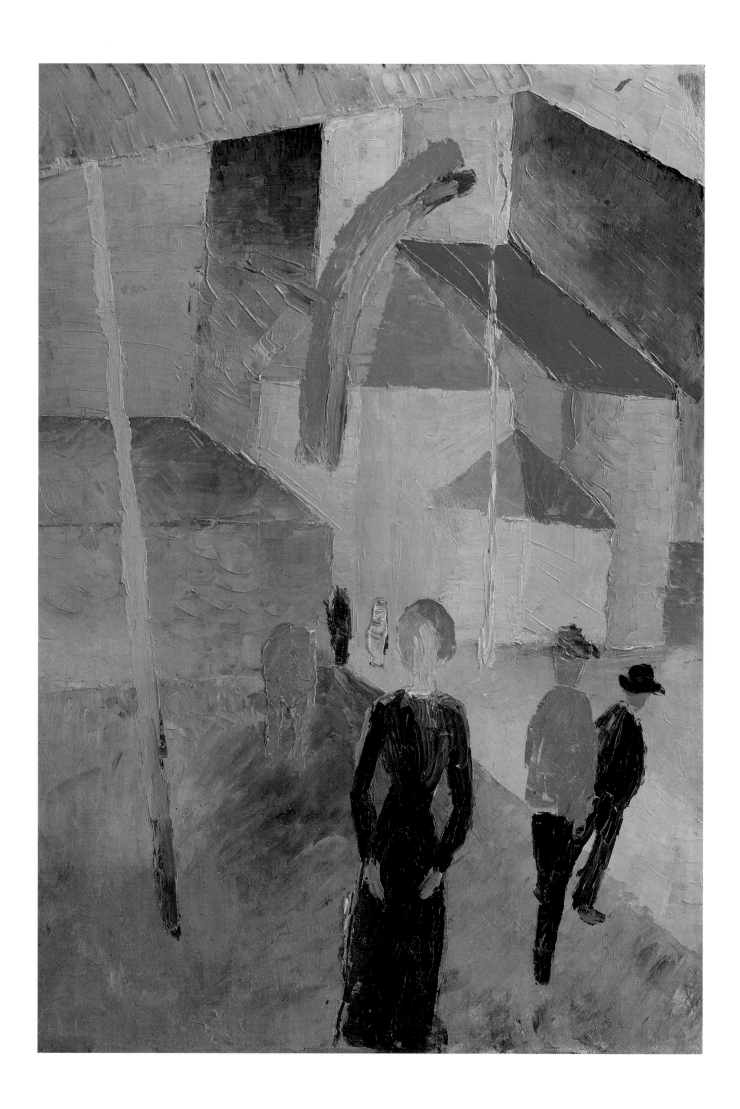

Macke and the "Rheinische Expressionismus"

While Dresden, Berlin and Munich were the three most important centres of the German avant-garde, as well as the cradles of German Expressionism, in the Rhineland, too, a circle of younger artists had formed around August Macke. The progressive ideas of these artists were influenced by French Impressionism, and by the latest advances and trends in international art. Although these highly individual talents never actually combined forces to establish themselves as a group, they entered art history together under the heading "Rheinischer Expressionismus" – thanks to the tireless endeavours of Macke, who succeeded in bringing these Rhineland painters together for an exhibition in Bonn in 1913.

Indeed, during his stay in Bonn from December 1910 until September 1913, Macke used whatever influence he had to spread the ideas of the artistic avant-garde – while at the same time intensifying his own artistic work. Macke's ambitious activism in organising exhibitions in the Rhineland also helped pave the way for the "modern" art of his southern German and French friends. Here, too, he was fortunate in being able to rely on the support of Bernhard Koehler, without whose financial assistance several of Macke's projects could never have been realised.

Immediately after his return from Tegernsee to Bonn, Macke became acquainted with a number of important representatives of Bonn and Cologne cultural life, including the director of the Cologne Museum of Arts and Crafts, Dr. Max Creutz; the director of the Wallraf-Richartz Museum, Alfred Hagelstange; Dr. Walter Cohen, directorial assistant at the Provincial Museum in Bonn, and the latter's brothers Friedrich and Heinrich Cohen, who ran the art and bookshop in Bonn where the "Rheinische Expressionismus" exhibition was shown.

Macke's circle of acquaintances in the Rhineland quickly expanded. The friendship he kept up with the Cologne family Worringer has already been mentioned. In 1911 Emmy Worringer, along with several other Cologne artists, had founded the "Cölner Sezession", in whose exhibitions Macke showed his work. She was also the director of the "Gereon Club", which Macke joined in 1911. This was a private association of artists, musicians, writers and art followers, named after the street in which the club's rooms were situated – in a building along with offices and studios. The Club organised concerts, lectures and exhibitions of contemporary art. Macke exerted a considerable influence on the Club's exhibition programme, also using the Club to champion the cause of his painting friends in Munich. It was thanks to Macke's efforts that an ex-

Three Nudes, 1913
Drei Akte
Linocut

Church with Flags, 1914
Beflaggte Kirche
Oil on canvas, 48 x 34 cm
Städtisches Museum, Mülheim an der Ruhr

hibition of the "Neue Künstlervereinigung", Munich, was shown there at the end of 1911. Macke himself held a lecture on this occasion, entitled "Words, Sounds, Colours", gaining an enthusiastic reception from his Rhineland audience. In January 1912, again upon Macke's recommendation, the "Gereon Club" showed the first "Blaue Reiter" exhibition, which had started at the Thannhauser Gallery in Munich; at Macke's instigation, the second exhibition was even shown at the Wallraf-Richartz Museum in Cologne.

Among Macke's most influential activities as an exhibition organiser was his contribution to the working group of the Cologne "Sonderbund" exhibition of 1912, the most important presentation of international modern art in Germany before the First World War; and also his plan for the first German "Herbstsalon" (Salon d'automne), an exhibition of international avant-garde painters which was shown at Herwarth Walden's gallery "Der Sturm" in Berlin.

It can hardly be disputed that Macke acquired an extraordinarily important role as a go-between in all these activities, and that he became well-known as a promoter of the arts. The question remains, however, whether Macke's organisational activity for the "Rheinische Expressionisten" also influenced their work, and, indeed, whether Macke's own work influenced that of his friends from the Rhineland.

The idea for the "Rheinische Expressionismus" exhibition was conceived in Grau-Rheindorf. A small colony of artists had established itself in this Bonn suburb, and its members met there regularly in a villa to paint and discuss art with other artists from the region – such as Max Ernst, who lived nearby in Brühl, Paul Adolf Seehaus, Otto Feldmann, Hans Thuar and, of course, Macke. Bonn, a university town full of pensioners, was not exactly open to new ideas and was hardly the kind of place to hold an exhibition of progressive Rhineland art. The project could therefore take nothing for granted, and would demand intensive preparation. Macke took responsibility for selecting the artists, also designing the poster and invitiation for the exhibition. From 10 July until 10 August 1913 sixty works by sixteen "Rheinische Expressionisten" were presented at the Friedrich Cohen Art and Bookshop, which was located centrally, opposite the university: besides Macke himself, there was his cousin Helmuth Macke, then Heinrich Campendonk, Ernst Moritz Engert, Max Ernst, Otto Feldmann, Franz Henseler, Franz M. Jansen, Joseph Kölschbach, Carlo Mense, Heinrich Nauen, Marie Nauen von Malachonski, Olga Oppenheim, Paul Adolf Seehaus, Wilhelm Straube and Hans Thuar. Macke maintained professional and personal relations with all these artists.

Macke's direct influence on the work of the artists exhibited in Bonn appears to have been restricted to a few individuals. What united these artists despite their heterogeneity in character was rather the desire they had in common to renew artistic expression on the basis of innovations already introduced by Cubism, Futurism and Orphism. The work of the "Rheinische Expressionisten" is best characterised by their openness to French and Italian models, and by their persistence in choosing figurative subjects.

These were also the salient features of Macke's work – which, in the

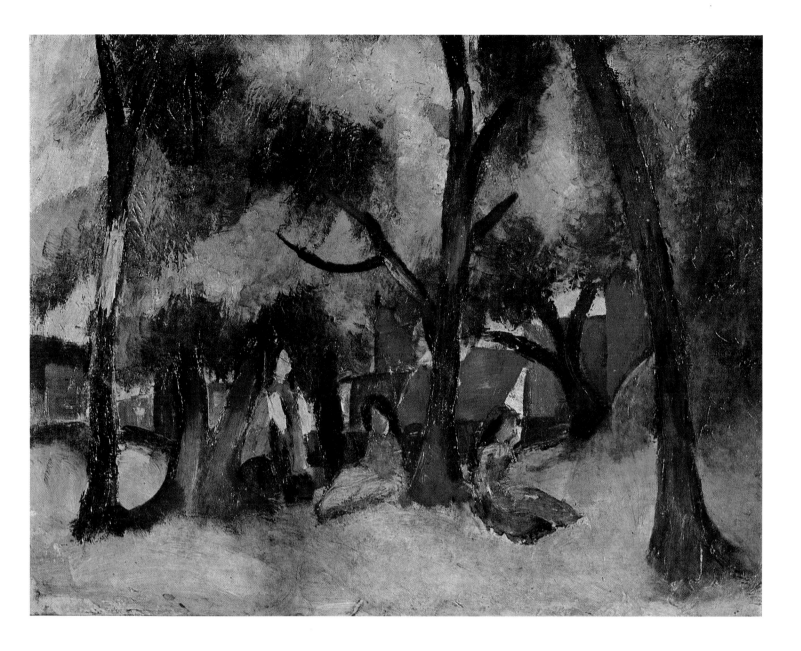

final analysis, distinguished him from the "Blaue Reiter" group. Macke found his own ideas confirmed in a tendency inherent among the "Rheinische Expressionisten" to "spiritualise nature", as it was termed, a tendency Macke himself referred to as "imbuing nature with joy".

Macke could not have chosen a better moment to discover the originality of Rhenish modernism. He had succeeded in assembling the artistic potential of the Rhineland, making a hitherto unknown centre of Expressionist art accessible to the public, while entering art history himself as its leading exponent.

Macke's brilliant organisational talent and the politics of his exhibitions also met with ill-will and outright antagonism. In order to recover from all this and concentrate once again on his own painting, he and Elisabeth moved – at the end of September 1913 – to Hilterfingen on the Lake of Thun. During the following eight months of his stay in Switzerland, Macke was to undergo yet another important phase in his artistic development. With his "excursions into cultural politics" in Bonn now put firmly behind him, he was at last able to return to his most important work – painting itself.

Children under Trees in Sun, 1913
Kinder unter sonnigen Bäumen
Oil on canvas, 42.5 x 56 cm
Staatsgalerie, Stuttgart

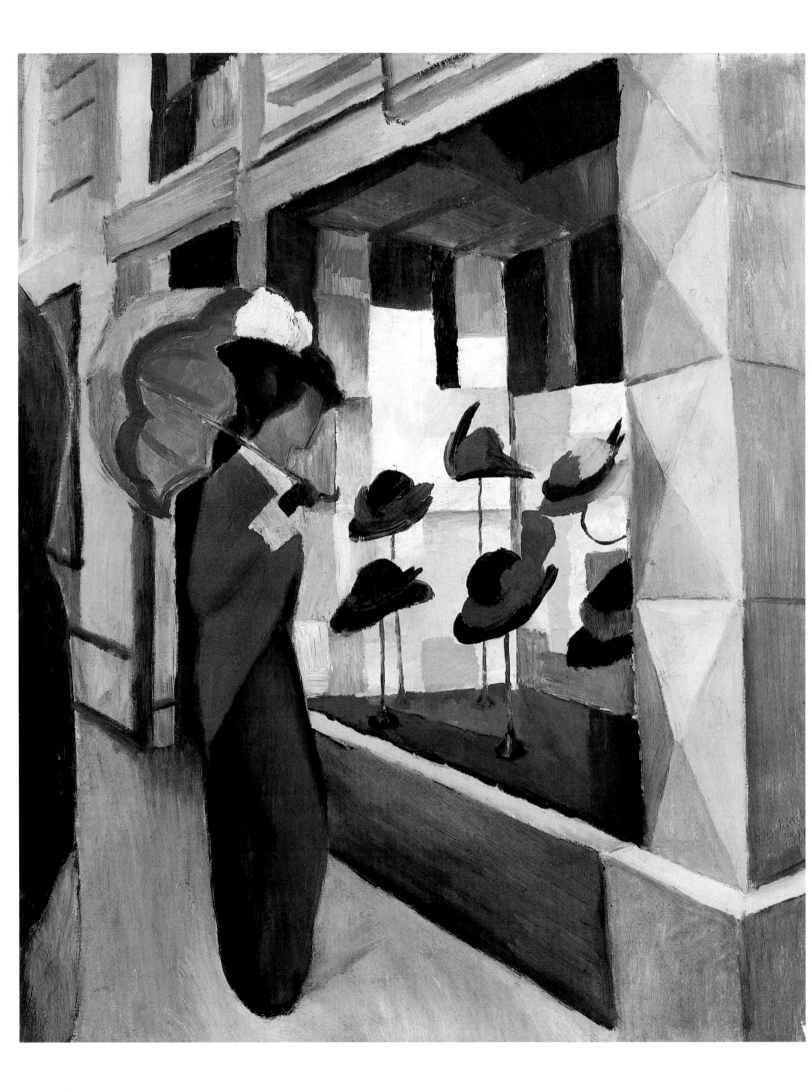

The World View of Macke's Pictorial World

Macke's work is distinguished by its unique formal qualities, and by stylistic innovations of considerable significance for "classical modernism". His subject matter, however, is less conspicuous, and less personal.

Macke never indulged in literary subjects, in history or "great" themes. If he showed any preference for particular subjects at all, then it is his paintings of the human figure which stand out most. Besides landscapes and still-lifes, the most frequently recurring themes of Macke's pictorial world are human figures and portraits. Macke does not involve his figures in a "plot" of any kind, nor does he show them carrying out specific tasks. He is not a narrator of dramatic events, nor does he record the "historic" moment. Instead, his human figures tend to remain passive, appearing detached and uninvolved. In fact, his street and park scenes are often peopled with faceless "extras", some sauntering aimlessly, some lingering – strollers, mothers and children, small groups of people standing about on streets and town squares, in parks, on the banks of rivers or lakes, or in zoological gardens. Macke's human figures often appear like "accessories", like set pieces introduced to suggest a certain cultural milieu.

Macke's interest in depicting the big city with its bustling boulevards and cabarets dates from his first visit to Paris in 1907 – as many of his sketches testify.

The "big city", made fashionable by the Impressionists, was now taken up with great gusto by the Expressionists. Urban themes were especially loved by artists associated with the "Brücke", like Ernst Ludwig Kirchner or Erich Heckel; but they were also popular with Ludwig Meidner, Max Beckmann and George Grosz. The Italian Futurists felt inspired by the noise and speed of the cities. The Parisian metropolis, with its symbols – like the Eiffel Tower – compressed to a system of pictorial cyphers, had also become the main theme of Delaunay's work.

The chaos and scintillating attractions of the city, which stimulated and agitated so many of his contemporaries, do not appear to have interested Macke as much. His descriptions are always limited to his own, ordered, middle-class surroundings; beyond that, sociological analysis is a topic which evidently remained foreign to him. Macke's towns and their inhabitants tend to be more provincial in character – not loud and uncontainable, but contemplative and self-contained. The motifs of his pictures are the merely components, or points of departure, of abstract compositions, into whose texture they are entirely woven, and within which they

Visiting the Parrots, 1914
Bei den Papageien
Crayon, 29.5 x 35 cm
Museum am Ostwall, Dortmund

Hat Shop, 1914
Hutladen
Oil on canvas, 60.5 x 50.5 cm
Museum Folkwang, Essen

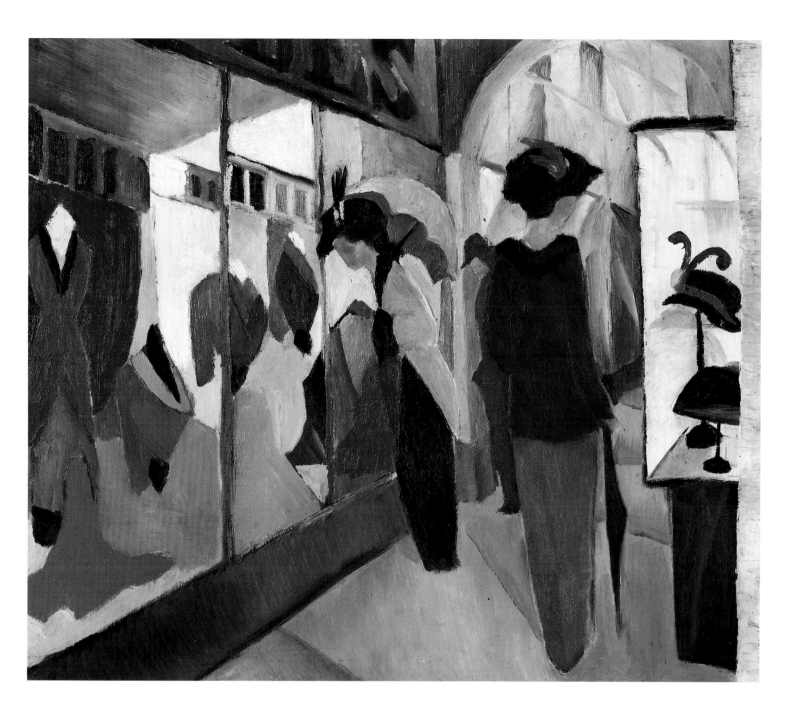

take their place as a matter of formal necessity. Beyond that formal necessity, their significance as subject matter is secondary.

In 1913/14 Macke spent eight months with his family on the Lake of Thun, in Switzerland, where his mother-in-law owned a house. This was to prove an extrordinarily productive period in his life. For it was here, living in the country, that his sense of distance from the town freed his hand, so to speak, for the development of urban themes: he now painted town and park landscapes, street scenes, views out and in through windows, theatres, acrobats and circus artistes. Macke also appears to have discovered his predilection for the shop-window motif at Hilterfingen, and in the nearby town of Thun.

The shop-window motif made its first appearance in Macke's work in a painting strongly influenced by Futurism: his *Large Bright Shop Window* (p. 47) of 1912. This was one of a group of "shop-window" paintings, most of which he completed at Hilterfingen, using motifs from the

Fashion Shop, 1913
Modegeschäft
Oil on canvas, 50.8 x 61 cm
Westfälisches Landesmuseum für Kunst und
Kulturgeschichte, Münster

Cathedral at Freiburg, Switzerland, 1914
Kathedrale zu Freiburg in der Schweiz
Oil on canvas, 60 x 50 cm
Kunstsammlung Nordrhein-Westfalen,
Düsseldorf

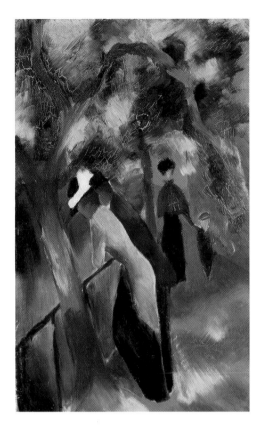

Sunlight Walk, 1913
Sonniger Weg
Oil on pasteboard, 50 x 30 cm
Westfälisches Landesmuseum für Kunst und
Kulturgeschichte, Münster

ILLUSTRATION PAGE 65:
People by a Blue Lake, 1913
Leute am blauen See
Oil on canvas, 60 x 48.5 cm
Staatliche Kunsthalle, Karlsruhe

ILLUSTRATION PAGES 66/67:
Large Zoological Garden (Triptych), 1913
Großer Zoologischer Garten (Triptychon)
Oil on canvas, 129.5 x 100 cm,
outer panels both 129.5 x 65 cm
Museum am Ostwall, Dortmund

picturesque little town of Thun; the group also included the painting *Fashion Shop* (p. 63) of 1913. This picture gives us a diagonal view of a covered walk in Thun – one of the old pedestrian colonnades with shops and glass showcases. On the left, the various sections of a long window display with brightly coloured ladies' fashions disappear into the arcade; at the same time, our view is partly blocked by the edge of a hat display looming into the picture on the right. Behind an arch which curves over the gallery, the vaulted passage-way leads off into the windowed depths of the picture. On the right, a slender lady, wearing a hat and carrying an umbrella, is inspecting the hat-display. A second lady on the left is turning to look at a shop-window. A further figure – somewhat abruptly fore-shortened in the middle distance – is suggested standing in profile under the arch. Although typically urban, the scene is neither loud nor hectic, but contemplative – like a stage setting. Despite its complicated diagonal stereoscopic effect, the picture space is clear and rationally organised, appearing to adhere to the picture surface in a series of spatially staggered planes. The fragmentary geometry of the individual shapes of the architecture, window-displays and slim, symbolic abstractions of human figures fit like stones into the mosaic of the overall composition; their colours, too, form an integrated whole, dominated by blue, and shot through with bright accents of yellow and red. The figure-space relationship seems to anticipate certain qualities developed ten years later in the "Bauhaus" works of Oskar Schlemmer.

The *Hat Shop* (p. 60), one of the last and most mature of this group of pictures, was not painted until 1914 in Bonn. Its subject, a display of hats in a shop-window rising diagonally from the foreground at the bottom right into the backgound at the left, may be a scene in Bonn; at the same time, however, the shop and window-display motif follows on from the Thun colonnade. The single figure of a lady in an elegant costume, wearing a hat decorated with a bouquet of white flowers and carrying a parasol over her shoulder, is a motif also found in *Fashion Shop*, painted the previous year at Hilterfingen. The grey stone facade and rustication of the corner-pillar may point to a "Gründerzeit" house in Bonn. The fashion worn by the lady, mainly warm reds and yellow, corresponds directly to that of the hats in the window display, which are adorned with gaily coloured bands and feathers, and decoratively arranged on stands. The window-pane refracts the play of lights and reflections, allowing an interpenetration of interior and exterior, surface and space. The crystalline reflections and staggered transparent planes are echoed by the diamond pattern of the rustication on the grey facade. As in all Macke's shop-window pictures, this woman, too, remains faceless, reduced to an anonymous statuette – like a tailor's dummy. Here, the greyness of everyday reality is eclipsed by the aura of luxury goods.

Among the qualities which captivate the viewer, and make this picture one of the most fascinating and convincing of all Macke's works, are the confidence and clarity of its balanced composition, the radiance and contrasts of its colours, and its natural combination of abstract composition and figurative description.

Another theme to which Macke turned his attention at Hilterfingen, besides the fashion and hat shops of Thun, was that of people in outdoor

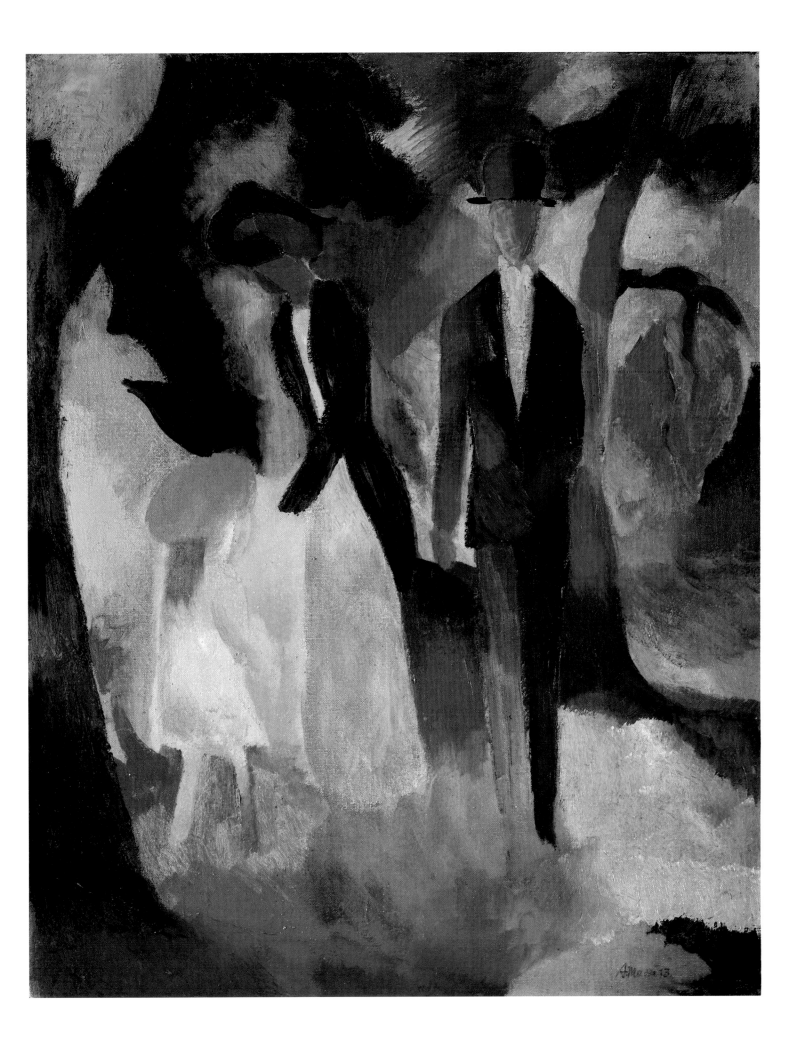

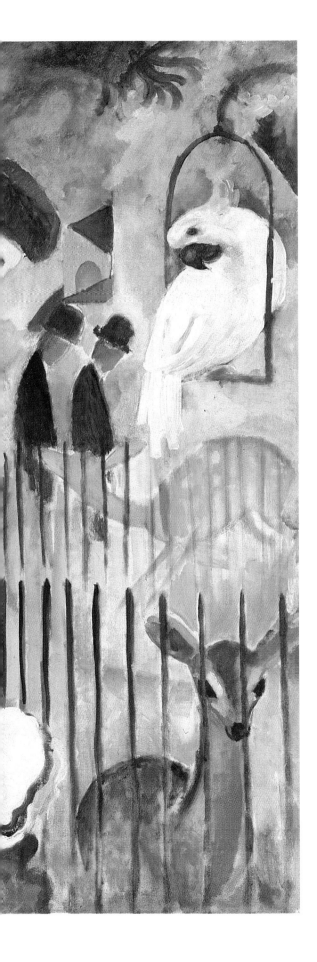
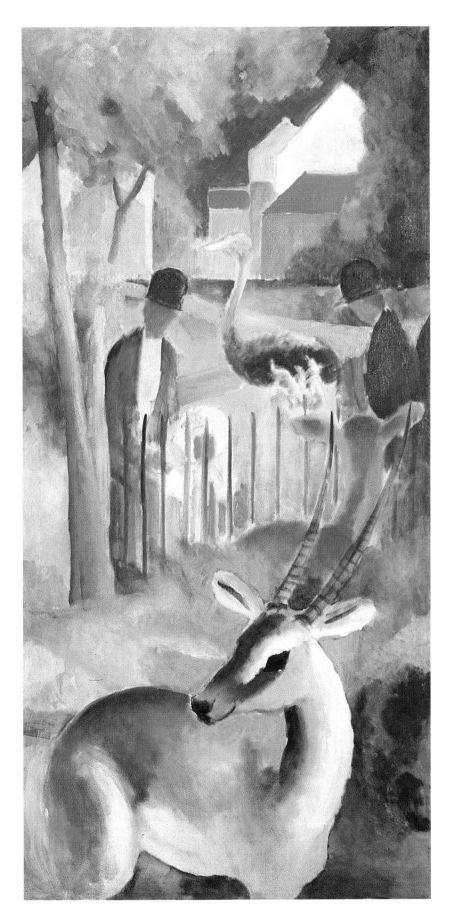

Visiting the Parrots, 1914
Bei den Papageien
Water-colour and body paints, 27 x 32 cm
Städtisches Museum, Mülheim an der Ruhr

surroundings: strollers – single figures, pairs or small groups – lingering under park trees or promenading on the banks of lakes, like guests at a health resort. The people he paints are always townsfolk against a background of urban greenery.

Lady in Green Jacket, People by a Blue Lake (p. 65), *Sunlight Walk* (p. 64) and several of the "Promenades", all painted at Hilterfingen in 1913, may be cited as examples of this group of bright, strongly coloured, but also highly atmospheric pictures. These paintings show a lighter touch, a tendency to replace geometric severity with flowing forms and blended areas of colour. While *Girls Bathing with Town in Background* (p. 53) of 1913, whose abstraction owes much to Cubism and Futurism, was structured as a multi-faceted arrangement of severe geometrical shapes, freer and lighter forms appeared in Macke's work in the late summer of the same year – a tendency which increased during the following year. From now on, Macke handled surfaces in a more painterly manner, making less use of sharp contrast while retaining the radiance of his colours. His continued, while relatively unconstrained use of abstract structures suggests greater formal confidence. The painterly gesture and surface structure of his pictures reveal an affinity to forms in Cézanne's later work.

These, more recent paintings are also related to the pictures of *Zoological Gardens* which Macke began in 1912, and which he prepared in countless drawings, showing elegant, urban parkscapes, in which human figures and animals are arranged ornamentally like the set pieces on a stage. His people and animals – deer, gazelles or antilopes, flamingos and brightly coloured parrots, but no wild or really exotic beasts – linger under sundrenched trees. These figures are composed as relatively unproblematic and inconspicuous motifs; in terms of colour and form, however, they are essential components. Macke turns these microcosmic scenes into abstract pictures; his painter's eye reflects upon his own abstraction of the world, and upon the rules of art itself, so that the problems of subject matter fade far into the background.

Macke's paintings showing people and animals in gardens have been described as "visions of paradise". However, interpretations in this vein tend to overestimate the role of content. The serene ease and lack of all tension of his sunny parkscapes, lakeside scenes and zoological gardens point less to the artist's preoccupation with questions of interpretation, than to his interest in finding abstract pictorial forms whose contents do not absorb the viewer's attention, or distract from the painting's abstract elements and structures. His apparently paradisial pictures are not necessarily intended to depict paradise; their effect is rather to annul the significance of their own subject matter.

One of Macke's largest, and certainly one of his most unusual paintings is his *Large Zoological Garden* (p. 66/67) of 1913. It seems as transparent as a water-colour, and yet is full of luminous, light colour. As a triptych – the traditional term for tripartite altar pieces – it is unique in Macke's work. This presents us with a problem. The triptych has a tradition, going back hundreds of years, which is rooted in sacred art – the "triptych as the formula of pathos". This lends the painting a certain gravity, and raises the problem of meaning. Does the form demand we in-

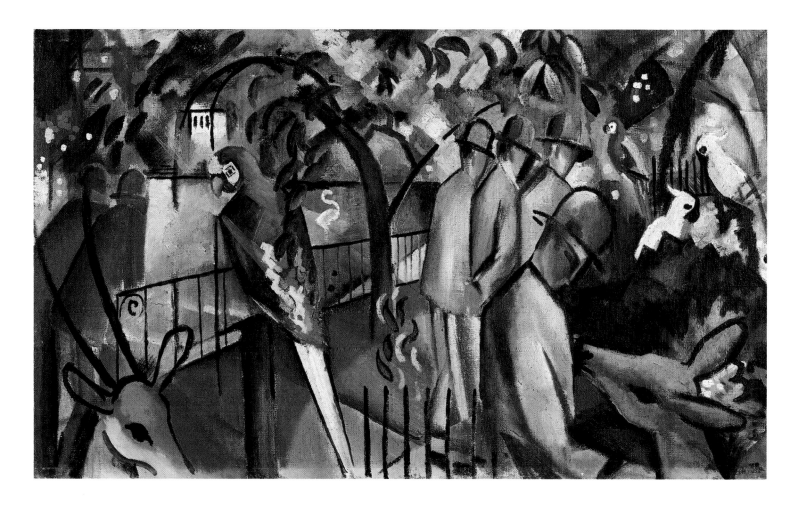

terpret this zoological garden as a garden of paradise? Does the use of a form usually found in altar pieces perhaps even suggest the biblical paradise? Is the artist making a deliberate statement? Whatever the answers to these questions, biblical allusions are altogether rare in Macke's work.

In fact, any definition of *Large Zoological Garden* as a triptych needs to be qualified. Although, like a triptych, the picture consists of three separate panels held together by one frame, the painting itself shows a single space and a single theme, while its vocabulary forms a bridge between the panels; thus, there appears to be a single picture-plane, while the sections into which the panels divide the picture seem superimposed. On the other hand, the picture is constructed according to the formal framing principles of the triptych, which, in turn, support the composition structurally. Thus, while the forms in the central panel are larger, and the objects occupy the foreground, the areas in the lateral panels are smaller, suggesting greater depth. It may even be felt that the central panel is more significant thematically, since three human figures, a mother and two children, take up the foreground, while the animals are fenced in, or are restricted to the background. This contrasts with the lateral panels, in which the human figures occupy the background, while the foreground is taken up by three herons on the left, and an antilope on the right. Macke's choice of the triptych as a form for *Large Zoological Garden* thus hardly seems dictated by chance.

Macke had already done paintings, drawings and studies of zoological gardens with people and animals under trees in 1912, probably inspired by visits to Cologne Zoo. The most important painting in this group,

Zoological Garden I, 1912
Zoologischer Garten I
Oil on canvas, 58.5 x 98 cm
Städtische Galerie im Lenbachhaus, Munich

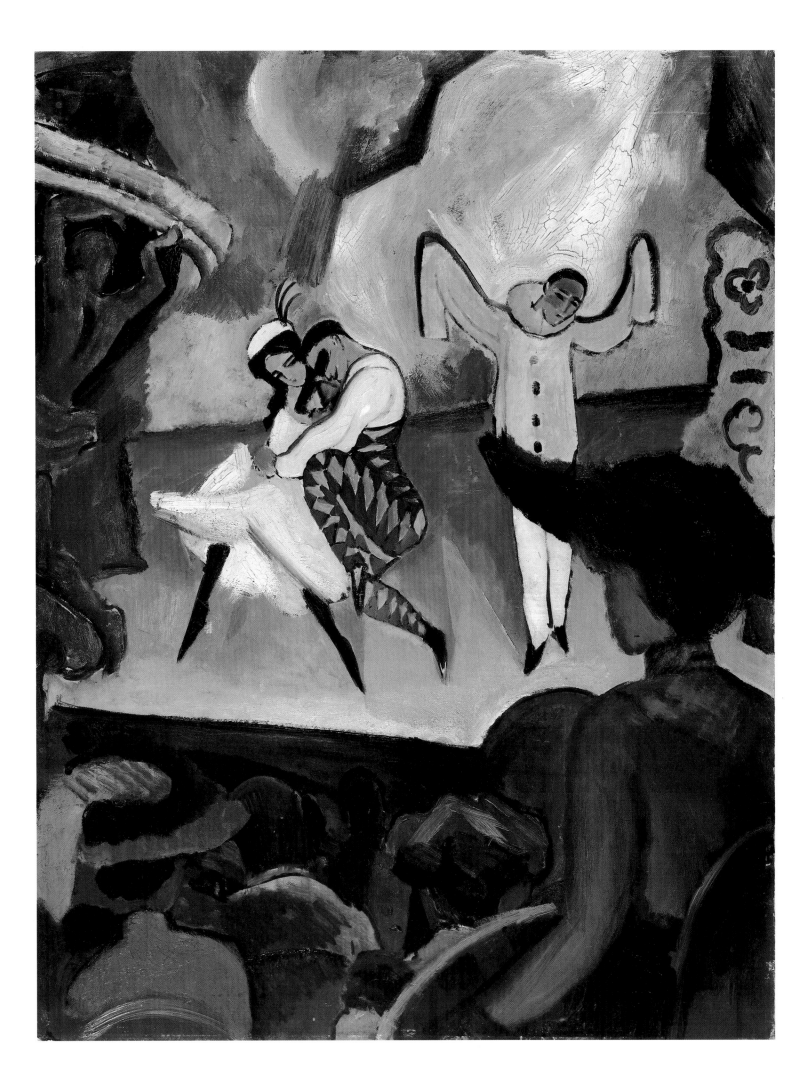

besides the Dortmund triptych, is his *Zoological Garden I* (p. 69), in Munich. With its smaller oblong format, the picture's proportions correspond conspicuously to those of the triptych. It has sometimes been seen as a diptych, whose two halves are framed by the round, arching branches of the tree in the centre. However, the composition can also be "read" as a triptych: the parrot on the left, and the male half-figure in the foreground on the right, divide the picture into three. The centre is marked by the tree, while the left and right "leaves" are occupied by the heads of animals, which are cut off by the bottom edge of the picture.

Whether diptychs or triptychs – and both are precious, sacred forms – neither of these pictures is intended as an altar-piece for some pantheistic, natural religion. Nevertheless, the compositions of both *Zoological Gardens* are divided into clear compartments, so that an abstract ordering framework appears superimposed on the depicted objects. If the triptych-like frame of the larger picture seems arbitrary, and less motivated by the immanent concerns of the composition, the smaller painting needs no external framework to show its clear division into zones, which, though abstract, derive from an ordering principle inherent in the depicted objects. This perhaps explains Macke's own higher estimation of the smaller, more coherent, and probably earlier *Zoological Garden*.

Scenes with acrobats which Macke turned into outstanding pictures in 1914, during the last year of his life, were yet another theme derived from the realm of middle-class, urban culture. In 1912, he had painted a related subject, *Russian Ballet* I (p. 70), inspired by Diaghilev's ballet "Carnival", which he had visited several times in Cologne in the autumn of 1912. The colourful heads of spectators rise from deep shadows beneath part of a stage, upon which we see the spirited dance of a harlequin and his Columbine, and the gesticulating figure of a white pierrot. A brightly coloured back-cloth fills the background at the top of the picture. The theatre-motif, with spectators cut off by the bottom of the picture, is strongly reminiscent of Daumier, and, more especially, of paintings by Degas. On the other hand, Macke's colours are more intense; in their almost unbroken luminosity, they are also more abstract, and therefore remind us of Seurat's treatment of a similar motif. Macke adapts these models to his own, highly individual methods of composition and colouring. The picture's energy comes from its deliberately calculated tensions, which are resolved by the finely balanced counterpoint of form and colour. The painting appears to owe more to the rounded, flowing forms of the Fauvists than to the Cubists and Futurists, whose sharp, angular forms dominate several of Macke's other works during this period.

The *Tightrope Walker* (p. 73) probably dates from the beginning of 1914. The idea for this significant picture appears to go back to the late summer or autumn of 1913, and was worked out in a rapidly completed series of sketches. In her memoires, Elisabeth recalls the attractions of the picturesque scenes that gave rise to this picture: "While the evenings were still mild, the famous Swiss family of artistes Knie would give occasional performances in the market-place at Thun. Often, the performers were tightrope walkers. The rope was stretched diagonally across the dark square, flanked on either side by a string of coloured lights. The houses and streets were shrouded in darkness. Above them was the night

Russian Ballet I, 1912
Russisches Ballett I
Oil on pasteboard, 103 x 81 cm
Kunsthalle, Bremen

sky, hung with stars. A mystical light fell upon the castle and church on the hill, so that they alone shone out in the dark. And the artistes, balanced at a dizzy height on their rope, dressed in bright silk and sequins, demonstrated their daredevil skills. It was a picture of exceptional colour, full of rare contrast."

In contrast with this description, the painting is a freely drawn, but highly compressed composition, whose pictorial transformation of its subject has distanced it from the event which may have originally inspired it. All the same, there is one way in which the theme and its formal treatment are intrinsically related: the same fine sense of balance characterises both the artiste's ability to walk the rope, and the artist's abilities in composing the painting. The foreground of the painting, like that of *Russian Ballet*, is occupied by spectators whose dark, but coloured backs draw the eye towards the centre of the picture where the brightly coloured tightrope walker mysteriously appears to float, balanced above, or rather amidst, the broken cubes of the roofscape. The luminosity and transparency of the colours, the angular, splintered geometry of the forms, and the linear organisation of the surface give the picture the appearance of an illuminated window, or of painted glass. This highly artificial picture of an artiste is, in fact, among the most mature of Macke's paintings.

It is hardly possible to describe Macke's subject matter without taking into account his preoccupation with form, or his stylistic development. His themes narrowly correspond to the development of form in his paintings; to exaggerate slightly, it is as if his themes and motifs, though necessary, were merely vehicles for his abstract intentions. Conversely, he seems to have seen the world through the eyes of the abstract artist – and to have painted this world view. At any rate, an analysis of Macke's themes is unlikely to be profitable without a look at his forms, especially if one wishes to avoid the dangers of attributing too much significance to the content of his later work.

However, Macke rarely renounced objects, motifs or themes entirely in his pictures, painting only very few completely abstract compositions. He derived his pictures from observation of the real world, digesting his impressions through a mental filtering process. In this sense, his pictures correspond to his view of the world; or, quite literally, they have their roots in his world view. Macke was a secular painter, whose artistic work was motivated by his thoroughly worldly sensual impressions and views.

Tightrope Walker, 1914
Seiltänzer
Oil on canvas, 82 x 60 cm
Städtisches Kunstmuseum, Bonn

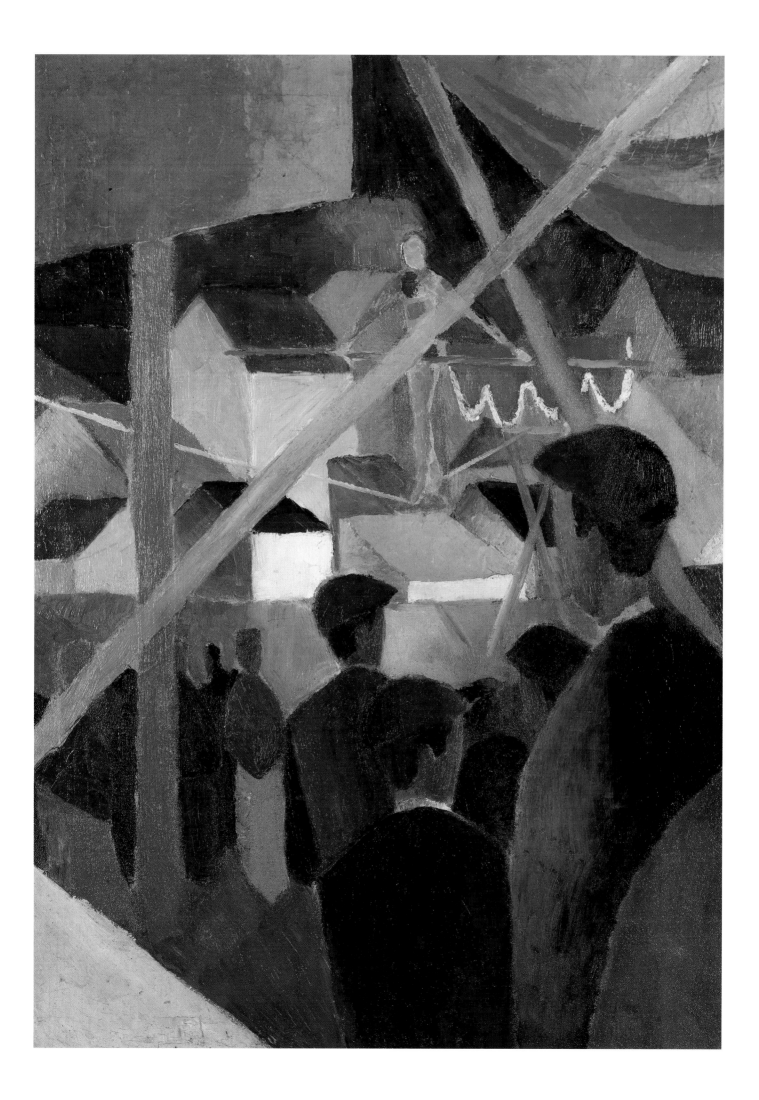

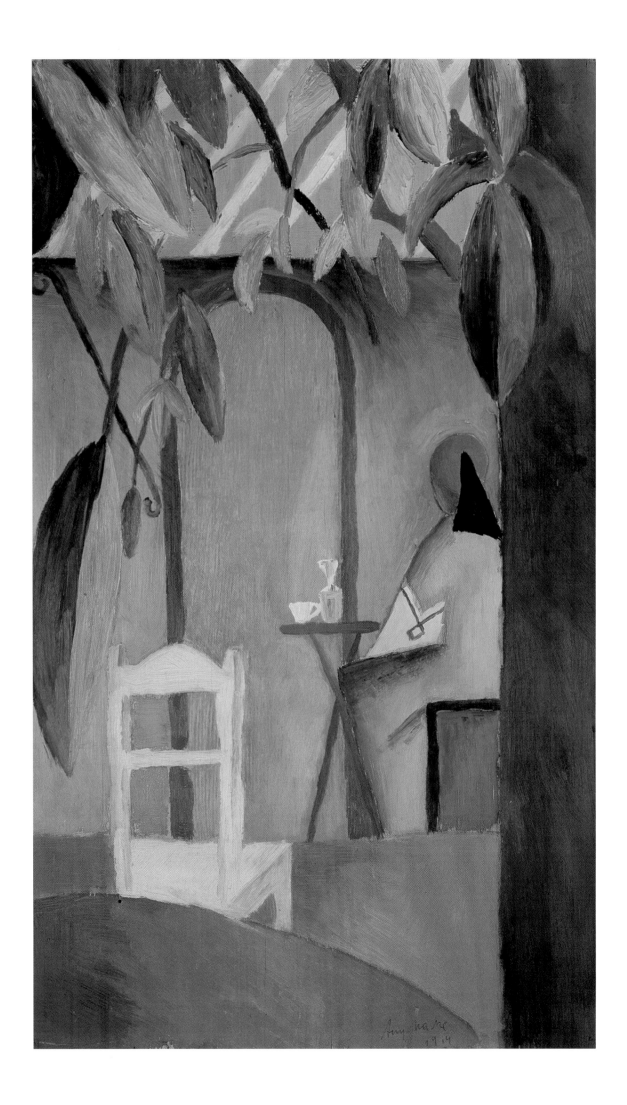

The Journey to Tunisia

Oriental motifs had always played a role in European art. In the nineteenth century, particularly since Romanticism, the imaginations of countless artists and writers had been fired by the exotic Orient. However, their image of the Orient usually had been quite distant from reality.

Oriental motifs can be traced back to 1910 in Macke's work: in his drawings and water-colours, as well as in textile designs and painted glass, where they entirely reflect Western notions of the Orient as a beguilingly sensual fairy-tale world brimming over with riches. Macke's interest in Oriental art had probably been awakened by his visit to the exhibition "Masterpieces of Mohammedan Art", shown at Munich in 1910. In 1914 a wish Macke had harboured for many years was fulfilled: he travelled to North Africa with his artist friends Paul Klee and Louis Moilliet. Although the trip lasted only fourteen days, it was to go down in art history as the famous "journey to Tunisia".

During his honeymoon in 1909, Macke had met the Swiss artist Louis Moilliet in Berne, and had formed a lasting friendship with him. Moilliet had introduced Klee to Macke in 1911. The idea of travelling together to Tunisia had arisen during a visit by Macke's friends to Hilterfingen on the Lake of Thun, where the Mackes had been living since October 1913.

The initiative for the plan had originally come from Klee, who was entirely unaffected by romantic longings for adventure. Inspired by the light and colour theories of Delaunay, which – as we have seen – had also left a deep impression on Macke, Klee wanted to explore the possibilites of such a journey for art, hoping for revelation in a Tunisian landscape flooded by the light of the African sun. It was to be an educational trip "in which each of us inspires the other", as Klee put it in a letter to Moilliet. Once again, Macke was able to rely on the financial support of Koehler, whom he promised to repay in the form of "a painting of a fat lady of the harem".

At the beginning of April 1914, Macke went on ahead, via Thun and Berne, to Marseille. On 5 April, his friends also arrived at Marseille, and all three crossed to Tunis in the "Carthago". Klee and Moilliet stayed with Moilliet's old friend Dr. Jaeggi, while Macke moved into a room in the "Grand Hotel de France".

Klee's diaries describe the course of the journey. To begin with, the friends spent several days with Dr. Jaeggi in his country house at St. Germain-sur-Mer, a Europeanised residential suburb on the outskirts of Tunis. They then travelled to Sidi-Bou-Said, visiting the remains of the

Turkish Café II, 1914
Türkisches Café II
Oil on wood, 60 x 35 cm
Städtische Galerie im Lenbachhaus,
Munich

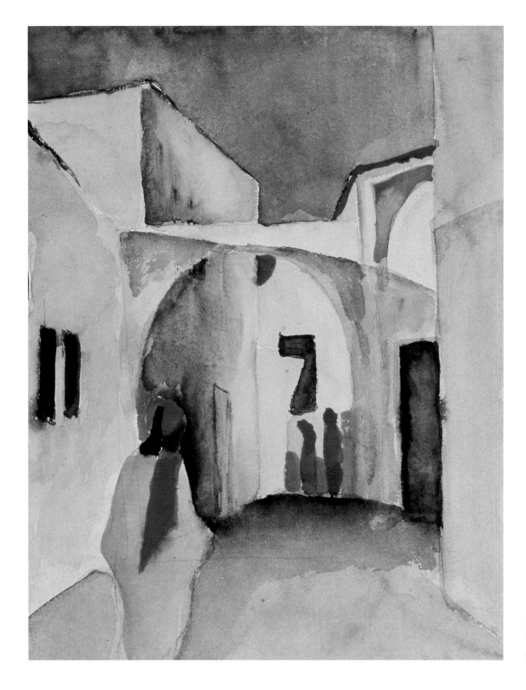

View of an Alley, 1914
Blick in eine Gasse
Water-colour, 29 x 22.5 cm
Städtisches Museum, Mülheim an der Ruhr

old town of Carthage. Following this, they went inland and saw the fa-
mous mosques of Hammamet and Kairuan. On 17 April they returned to
Tunis. Five days later, Macke and Moilliet were on their way home.

During this short trip, Macke produced work of astounding quality;
all his previous experience as an artist seemed to pour itself into this
work in concentrated form, giving it an expressive power which was
heightened even further by the southern sky and the light of the African
sun. Macke explored this new country and its foreign culture with almost
childlike curiosity – overwhelmed by the rich colours of the bustling, nar-
row streets and oriental markets, the bazaars and cafés; full of enthusi-
asm for the Moorish architecture, strange vegetation and exotic animals;
ecstatic over a sun which flooded everything in its radiant light. Filled
with energy, Macke immediately began to capture this inexhaustable
wealth of motifs and observation in pictorial form.

He also collected his impressions in a letter to Elisabeth: "Here we

are," he wrote, "sitting in the middle of the African countryside, drawing, writing – Klee is doing a water-colour. This morning I walked around the town and did some work. African countryside is even more beautiful than Provence. I would never have thought it. There is a Bedouin camp with black tents situated not 200 paces from where I am sitting; we are surrounded by herds of donkeys, camels etc. (. . .) Yesterday we walked through various Arab seraglios. The women were sitting or standing by their doors in the sun. A wonderful sight. Everything was so gaily coloured, and so clear – like church windows. (. . .)"

For practical reasons, Macke had not taken oil paints, but only a box of water-colours, several sketchbooks and a camera. His artistic output during this short trip was remarkable: 38 water-colours, more than a hundred drawings, and a large number of photographs. But above all, it is Macke's masterly water-colours which account for the legendary reputation of his journey to Tunisia. The water-colour demands a sure hand and considerable prowess, almost prohibiting correction; this is especially true when the paint dries as rapidly as it does in the hot climate of Tunisia. The fleeting impressions which Macke captured on the spot in his photographs and drawings served as models for his later, more elaborate compositions; at the same time, they provided a store of motifs for the paintings he was to complete upon his return from North Africa. "I think I'll be bringing an enormous amount of material home which I'll only be able to work on when I get back to Bonn", he wrote to his wife from St. Germain.

In a catalogue commemorating Macke's 100th birthday, Ernst-Gerhard Güse divides the drawings and water-colours Macke produced during his Tunisian trip into two groups: he distinguishes between pictures which "were executed directly before the objects they depict, and those which contain Tunisian motifs without referring to an actually existing situation". On the one hand, therefore, there are sketches, whose few, rapidly executed lines and planes define them as impressions recorded at a particular moment, and on the other, freer compositions, constructed from various fragments of Macke's sketches and photographs, and mostly completed at a later date.

The water-colour *View of an Alley* (p. 76), despite its strict pictorial order, may be classed with the first group. Its charm resides in the clarity and simplicity of its organisation, as well as in its radiant colours. A few pencil strokes reveal the outlines of the composition. The motif appears to show a detail of a narrow street in the Arab quarter of Tunis, with an archway in the background. This water-colour with its vertical format dispenses entirely with narrative or illustrative aspects. Instead, Macke captures a momentary impression, expressing pictorial volume through integrated areas of colour which recede from the eye in a series of staggered planes. He has not, therefore, dispensed with perspective; on the contrary, the yellow back of a robed figure in the foreground draws the eye into the depth of an alley which, despite its narrowness, is flooded with light. The shadowy silhouettes in the background, too, support the illusion of spatial extension. The picture is nevertheless dominated by flat surface forms; these disturb perpsective, interrupting the fluidity of spatial recession.

Although Macke has not abandoned representation in this water-colour, it is above all the structuring of colour and rhythmic organisation of the picture-plane which occupy his attention. The painting is dominated by unusually luminous, but finely nuanced tones of washed or overlapping blue and yellow. These main chords are accentuated by compressed areas of complementary colour, providing a bright and lively contrast to the measured quietude of the primary tones.

Macke's work in Tunisia reveals the persistence of a process begun at Hilterfingen: the transformation of objective reality into a non-representational medium. In this picture, too, Macke translates the physical qualities of the objects into the meta-physics of the pure African light absorbed by his water-colours.

The two water-colours which followed this, *Courtyard of a Villa at St. Germain* (p. 79) and *Landscape near Hammamet* (p. 80), are also among those painted directly from nature. Both are constructed from smaller components, however. The *Courtyard of a Villa at St. Germain*, incidentally, does not depict Dr. Jaeggi's house, but is probably a courtyard in the neighbourhood.

The days Macke spent by the sea in St. Germain were undoubtedly his most productive in Tunisia. Macke writes of his stay there in his only letter to Elisabeth: "We spend our time lying in the sun, eating asparagus etc. But you only have to turn round to find thousands of potential motifs. I've done 50 sketches today alone. Yesterday, I did 25. I'm working like blazes, and enjoying it like never before."

The spontaneously executed water-colour of a St. Germain courtyard was composed with very few strokes of Macke's pencil. Its motifs and representational forms are subjugated to a pattern of flat areas of colour, giving the appearance of a textile design. Their full integration within the play of lines and planes turn these figurative elements into part of an abstract system of forms and colours. There is a pronounced tendency here to replace linear perspective by dividing the picture-plane into two-dimensional surfaces. In his use of pure, light, saturated colour, Macke is guided by the serenity of Delaunay's Orphism, whereas his geometrical simplification of pictorial order betrays the influence of Cubism.

Macke also captured the picturesque harbour of Hammamet in a water-colour. This picture is divided into two zones: in the foreground, there is a colourful jumble of boats, cases, barrels, camels and mules; the background is taken up by a chain of hills under a blue sky. Macke does not dispense here with perspective as a traditional principle of organisation; nevertheless, the multi-coloured confusion of objects in the foreground shows a tendency towards the decorative, abstract reduction of figurative elements to flat areas, while the rich colour contrasts contain an echo of Fauvist colouring.

The rigorous pictorial arrangement of *Kairuan III* (p. 81) suggests that this water-colour is not the product of an immediate response to visual impressions, but was composed some time later using a combination of architectonic motifs found in different places. Macke has divided the picture-plane into coloured stripes of different width, which give the picture its disciplined structure. The architectural components – the domes and towers of mosques – are integrated into this vertical organisation of

Courtyard of a Villa at St. Germain, 1914
Innenhof des Landhauses in St. Germain
Water-colour, 26.5 x 20.5 cm
Städtisches Kunstmuseum, Bonn

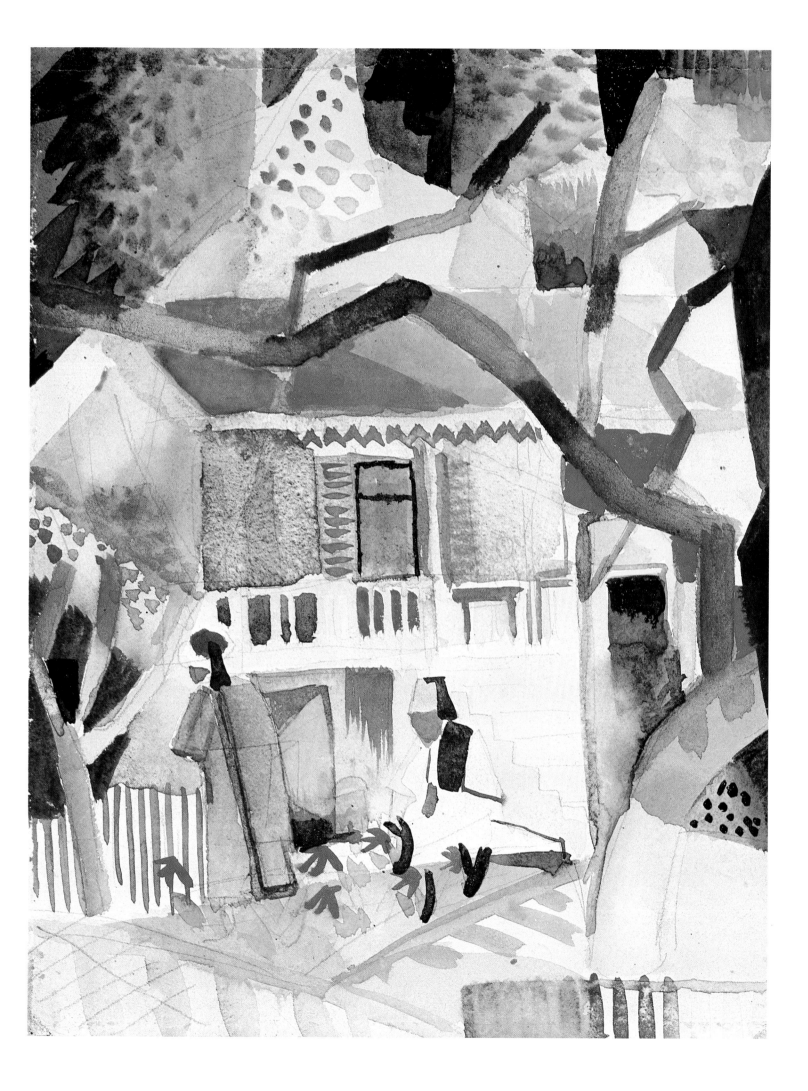

space, while the human figures on the right and the camel on the left seem like foreign bodies. The objects in the picture are arranged in rhythmical sequence and fully absorbed into the abstract pictorial order. The beauty of this colourful, transparent water-colour is that, even in retrospect, Macke has succeeded in reproducing the radiance of Tunisian light. It clearly reveals Macke's approximation to Klee's use of quadratic and oblong structures, without itself becoming wholly abstract.

Accompanied by Moilliet, Macke returned to Switzerland via Palermo and Rome. Before setting off for home in Bonn, however, he spent several weeks in Hilterfingen. From here, he wrote to Bernhard Koehler: "Our trip was really delightful. I strongly advise you to do the same. It's incredibly interesting. I worked a great deal, but my problem now is what to do with all the material. At the moment I still feel quite unhappy about it. I feel like a bull, run out of its dark stall into a beautifully done-up bull-ring; whichever way it turns, it gets sharp points stuck into it by brightly dressed little men". In Hilterfingen, and later in Bonn, Macke completed oil-paintings after Tunisian motifs, either drawing his subject

Landscape near Hammamet, 1914
Landschaft bei Hammamet
Water-colour, 21 x 26.5 cm
Westfälisches Landesmuseum für Kunst und
Kulturgeschichte, Münster

Kairuan III, 1914
Kairuan III
Water-colour, 29 x 22.5 cm
Westfälisches Landesmuseum für Kunst und
Kulturgeschichte, Münster

matter from the rich store of materials he had brought back with him, or recreating it imaginatively – or from memory.

There are two painted versions of *Turkish Café* (p. 74 and p. 83), whose composition is based on sketches undertaken in Tunisia. In his paintings, however, Macke has eliminated every sign of the highly detailed, pulsating dynamism of the sketches. In each of the paintings, an Arab figure, wearing a fez and kaftan, is depicted sitting at a table in a café. There is no sign of spontaneous facture; the human figures and objects seem frozen, and are rigorously subjugated to the abstract composition. The precise organisation of the picture-plane determines the pictorial order, whose elements are rendered in an explanatory vocabulary of simplified, geometrical forms. The composition is dominated by large blocks of colour; thus, the entirely plain and simple yellow cube diagonally facing us on the right of *Turkish Café I* represents a house. In both paintings, spatial relationships are largely dissolved in favour of flat surfaces.

Here, Macke replaces the transparency of his water-colours with more

highly saturated colours, whose fullness seems to exude intense heat and extreme radiance. Both paintings are among his greatest achievements. Macke gave the second of the two renderings to Bernhard Koehler, as a token of his gratitude for the latter's generositiy in supporting his trip to Tunisia.

Again, in *Landscape with Cows and Camel* (p. 84) and *Turkish Jewel-Trader* (p. 85), Macke uses oriental motifs; and here, too, he is less interested in the subject-matter itself than in formal phenomena. Unlike the monumental forms of the "Café" pictures, the components in these paintings are smaller, as if the picture surface, viewed through the finely-meshed grid of a carpet-designer, had been divided up into segments. *Landscape with Cows and Camel* is constructed as a mosaic of small, brightly-coloured rhombic forms, in which animals and plants are interwoven with the background to form a single structure. The painting *Turkish Jewel-Trader* itself resembles a jewel case full of precious stones. Here, Macke has dispensed with perspective in favour of the juxtaposition of coloured shapes on a two-dimensional plane. Instead of luminous areas of colour, he paints a chiaroscuro in smaller shapes. These paintings continue the tendency, observed in the water-colours Macke completed in Tunisia, to seek a balance between representational and non-representational elements. Macke's "journey to Tunisia" was the practical application of Worringer's theoretical doctrine in "Abstraction and Empathy" – its translation into the language of the senses.

Nevertheless, the trip was not a turning-point in Macke's life, nor did it demand of him a stylistic reorientation of any kind. Instead, the pure, bright claritiy of the African light enhanced the expressive appeal of his colours, and consolidated the power of his pictorial vocabulary.

ILLUSTRATION PAGE 83:
Turkish Café I, 1914
Türkisches Café I
Oil on plywood, 35.5 x 25 cm
Städtisches Kunstmuseum, Bonn

ILLUSTRATION PAGE 84:
Landscape with Cows and Camel, 1914
Landschaft mit Kühen und Kamel
Oil on canvas, 47 x 54 cm
Kunsthaus Zürich, Zurich

ILLUSTRATION PAGE 85:
Turkish Jewel-Trader, 1914
Türkischer Schmuckhändler
Oil on pasteboard, 29 x 19 cm
Leopold-Hoesch-Museum, Düren

The Perfection of the Unfinished

When Macke returned to Bonn, he had only a few weeks left to live. The short period that remained before he was called up would prove to be his last period of concentrated work as an artist. In her memoires, Elisabeth wrote of this period: "After his return, he plunged into work with great zeal. He worked in his studio, surrounded by some of his most important pictures. He had completed seventeen oil-paintings in Hilterfingen (besides water-colours and drawings). He finished two of these in Bonn. Then, in the weeks that followed, he produced thirty-six paintings, some of which were highly idiosyncratic. It is almost impossible to imagine how he managed to paint so many of his best pictures in such a short space of time. He seemed to work in a state of frenzy, in a fever, as if he were trying to get as much done as possible of the work he had set himself".

As we have already seen, a variety of styles had influenced Macke's work since his stay at Hilterfingen in 1913. After his trip to Tunisia, he continued to give equal weight to different styles. Besides composing rigidly structured arrangements of geometrical shapes and brilliant colour, he painted dynamic Futurist works, or combined elements of both styles in one painting.

In 1914, however, several new tendencies, probably echoes of his stay in Tunisia, began to make their presence felt. He painted a series of pictures whose soft contours seemed about to evaporate, and whose objects appeared to dissolve in coloured light. Here was a completely new Macke, a "painterly" Macke, who, in these exquisite examples of "peinture", seemed purged of all extraneous influence.

One of the most beautiful paintings of this last period is his *Girls under Trees* (p. 88), which Macke had begun in Hilterfingen, and had completed after his return to Bonn. In bright, glowing colours, Macke captures the serene mood of a group of girls who are totally absorbed with each other, and with their natural surroundings. He strengthens the perspective and dynamism of the pictorial order by arranging the figures in the foreground, who are cut off by the bottom edge of the picture, at a slight slant, allowing them to recede from the eye in a series of staggered planes. The front, profile and back views of these three girls correspond to the positions of three, more closely grouped girls standing in the background. Formally, and through the coherent structure of Macke's light brushwork, the human figures and their natural surroundings are densely interwoven. The balanced colouring dissolves the depicted objects in

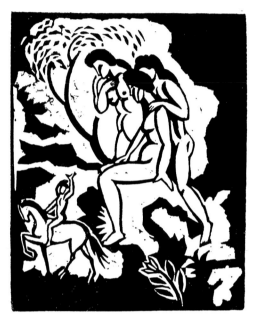

Leave-taking, 1913
Der Abschied
Woodcut

Red House in a Park, 1914
Rotes Haus im Park
Oil on canvas, 60 x 80 cm
Städtisches Kunstmuseum, Bonn

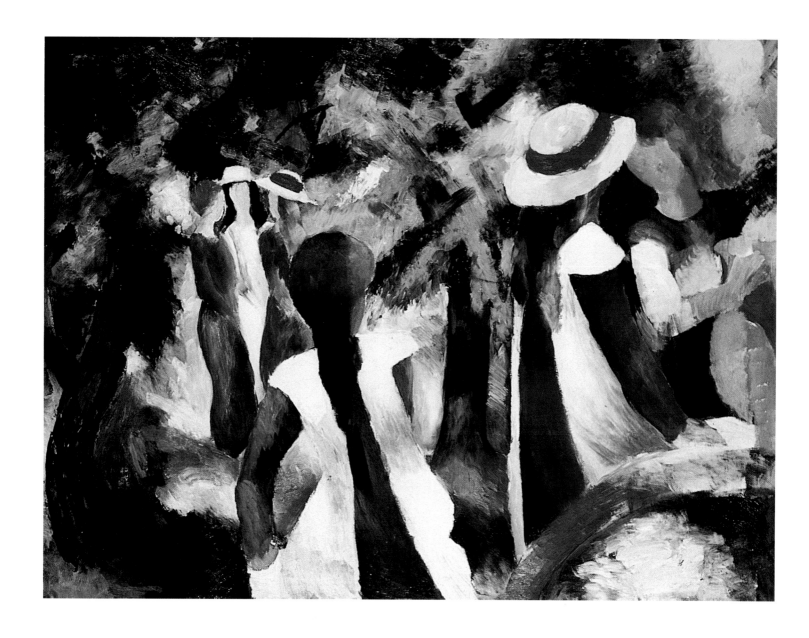

Girls under Trees, 1914
Mädchen unter Bäumen
Oil on canvas, 119.5 x 159 cm
Bayerische Staatsgemäldesammlungen, Staats-
galerie moderner Kunst, Munich

Woman in Park, 1914
Frau im Park
Oil on canvas, 38 x 23 cm
Collection The Museum of Modern Art, New
York

painterly form, allowing them substance only as coloured sounds – as
powerful chords in counterpoint, or as the ripple of soft glissandi. The
paint is delicately applied, with generous brushstrokes and passages of
flowing, partly overlapping colour. The radiant, dematerialising effect of
the Tunisian light seems to have transfigured the dull Rhenish sky over
Bonn, wholly pervading the artist's colouring. The painting expresses an
almost utopian vision: an incontestable belief in an undisturbed harmony
between human beings and nature. Appropriately, this "earthly paradise",
this "nature embued with joy", as Macke put it, is mirrored in the paint-
ing's own perfectly harmonious correspondence between form and con-
tent. "Even in the games of children," Macke once wrote, "even in the
hat of a cocotte, in our joy at a sunny day, invisible ideas gently assume
material form". Here, it is as if he had translated those words into paint-
ing.

Among these last, delicately executed compositions, in which the
human figure and its natural surroundings merge to form a tranquil and
harmonious whole, there is also the painting *Man Reading in a Park* (p.
91). The greens and yellows of the foliage and bushes, and intense blue
of the sky and park-bench, appear to shine from within, an effect height-

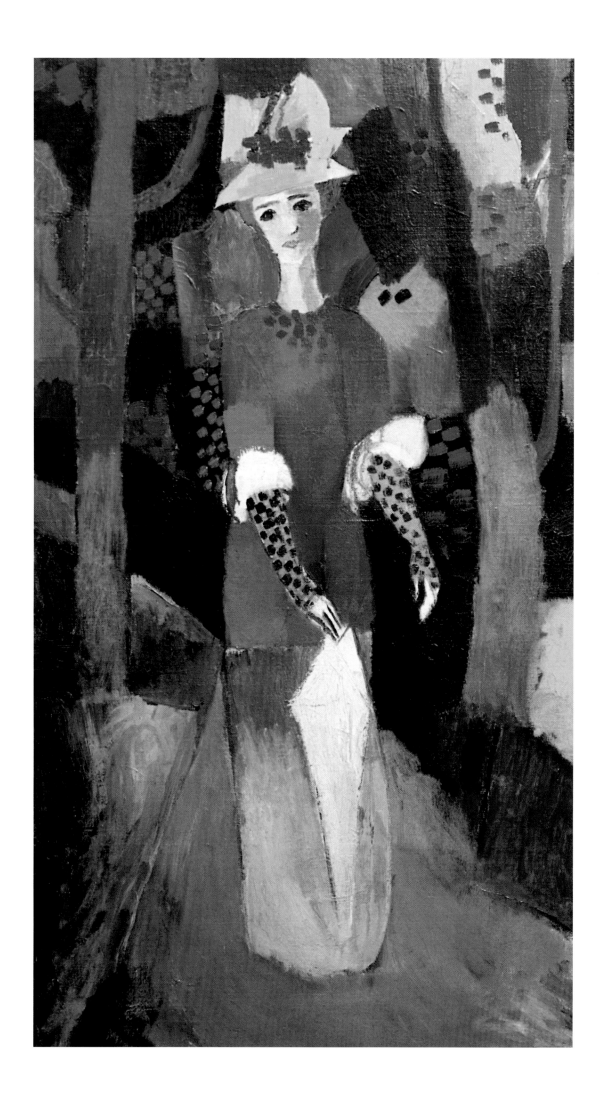

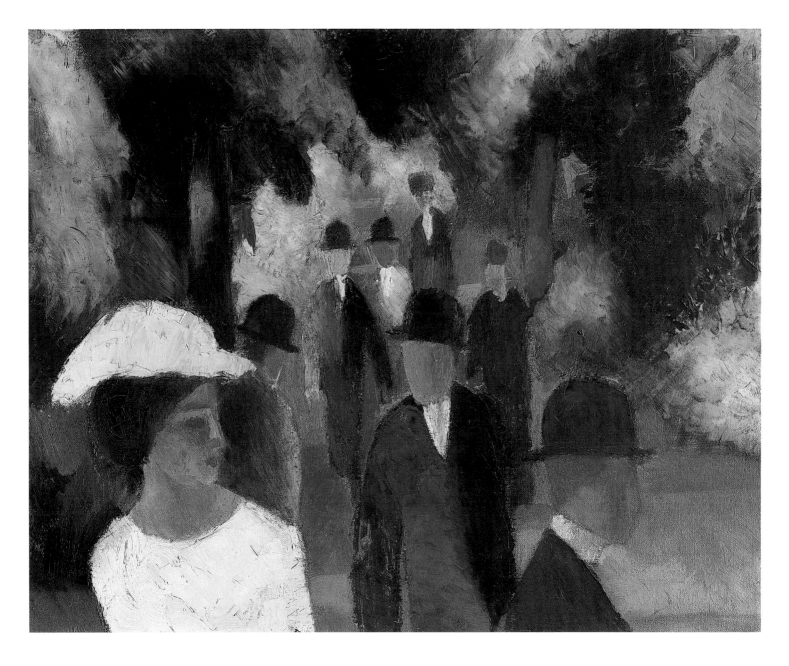

ened by the dark contrasts of the black and brown tree trunks and shadows of the leaves.

By contrast, the *Red House in a Park* (p. 86) is made to seem uncanny through the intense luminosity of its colours, especially its glowing red. The house, the path and the tree trunks seem to glow from within, in a manner not unlike the gleam of sunlight through stained glass.

Macke's personal handwriting of "dissolved" forms and the soft gay colours of his last pictures have induced some critics to interpret this last change in Macke's style as a return "to his artistic origins", or "to an Impressionist feeling for form and colour" (Magdalena M. Moeller). There is often also a marked tendency to speak of Macke's "late style" in this context. It seems hardly applicable, however, and somewhat exaggerated to speak of a "late style" in the work of an artist so young. Furthermore, these paintings can only be described as "Impressionist" in a very superficial sense. It would be more exact to speak of a synthesis of all the impressions and influences which had hitherto determined Macke's de-

Promenade (with Half-Length of Girl in White), 1914
Promenade (mit weißem Mädchen in Halbfigur)
Oil on canvas, 48 x 60 cm
Staatsgalerie, Stuttgart

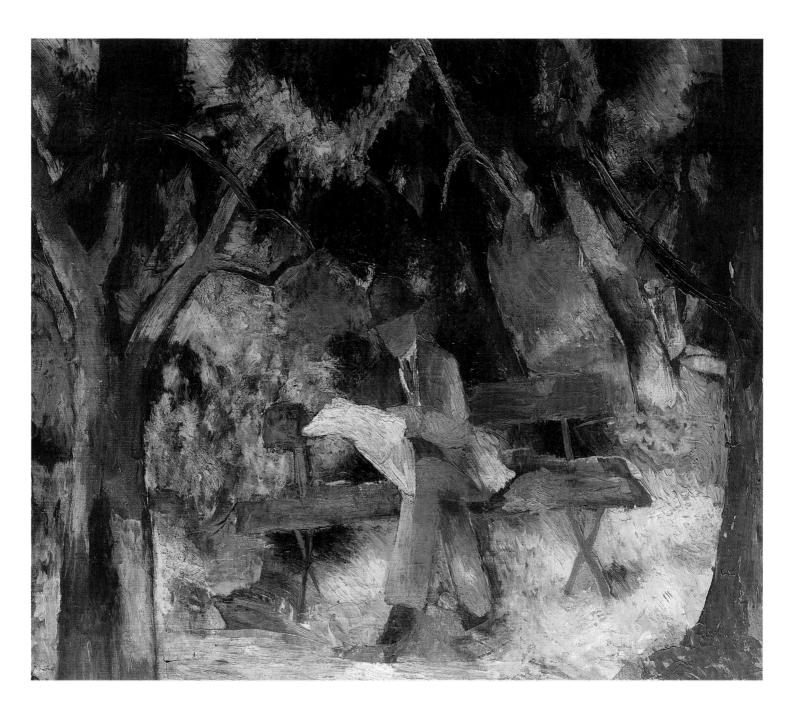

Man Reading in a Park, 1914
Lesender Mann im Park
Oil on canvas, 86.5 x 100.3 cm
Museum Ludwig, Cologne

velopment as an artist. As far as their intention is concerned, however, these paintings can be classed as wholly Expressionist.

It perhaps seems surprising that Macke's last paintings reveal nothing of the crisis of the times, no premonition or fear of the coming war; on the contrary, even in these last few months before the outbreak of war, his pictures express a pure sense of harmony. His friend Marc, like Macke, did not survive the war, falling in France in 1916, two years after Macke. Unlike Macke, however, Marc's premonitions of approaching collapse – the collapse of a whole era and whole continent – were registered seismographically in several of his later works of 1913 and 1914: in pictures like *Animal Destinies, Tirol* and *Fighting Forms.*

Was Macke an escapist? Did he deliberately shut his eyes to a reality which was both spiritually and physically threatening – a reality which finally destroyed him – and seek consolation in the harmony of art? Was his work therefore a consious flight from the outside world, from the real world and its threats – a flight from reality into art?

Macke's pictures, even his last paintings during the summer of 1914, contain moods of great peace and serenity, and testify to his harmonious view of the world – a view untroubled by anxiety. Macke's character was entirely of this world; he had a natural enthusiasm for life, and took a delight in all things worldly. It is quite possible that his work as an artist helped him to look beyond the dark side of human existence. Perhaps his art helped him reconcile himself to the dangers of the world, allowing him visions of distant harmonies of ethereal light beyond life's darkest abyss.

Only in one painting, one of his very last, does Macke appear to have registered the imminence of war and – perhaps – to have considered the possibility of his own death, capturing this, at least partly, in pictorial form. This unfinished painting contains a sense of decline and death, of fear and grief; it was only later that it was given its title *Leave-taking* (p. 93), and that its solemn colouring was interpreted as a premonition of death. The dark figures, reduced to rhythmically grouped, black silhouettes and contours, woven into a pattern of vertically arranged forms, look like people in mourning, like "pleurants" bewailing the dead at a burial. In mood, the painting is slightly reminiscent of the *Death Chamber*, and of other pictures of death by Edvard Munch.

On 8 August 1914 Macke was called up for military service. On 20 September, he was awarded the "Iron Cross" as an officer cadet. During the early morning of 26 September, he was killed in action south of the village of Perthes-les-Hurles, Champagne. He was twenty-seven. He was buried along with several of his dead comrades in a military cemetary in nearby Souain. Under the many unknown names inscribed on the war memorial, we find the simple words:

"(. . .) 26.9.1914 MACKE AUGUST FELDWEBELLEUTNANT (. . .)"

Franz Marc, who hardly had begun to grasp the full dimensions of a World War to which he himself was to fall a victim, wrote an obiturary on his friend and companion, which included the follwing words: "August Macke – 'young Macke' – is dead. Those who have followed the course of the new German art during these last, eventful years, those who sensed what the future held in store for the development of that art, also knew Macke. And those of us who worked with him – we, his friends, we knew what promise this man of genius secretly bore in him. His life described one of the boldest and most beautiful curves in the development of German art; with his death, that curve has been rudely broken. There is not one among us who can take it further. Each of us goes his own way; wherever our paths meet, we shall feel his absence. We painters know that without his harmonies, whole octaves of colour will disappear from German art, and the sounds of the colours remaining will become duller and sharper. He gave a brighter and purer sound to colour than any of us; he gave it the clarity and brightness of his whole being".

Marc was proved all too right: Macke's death, Marc's own death – in short, the World War – really did extinguish the ardour and powerful luminosity of Expressionist colour. The colours became duller, the forms and themes harsher, more pointed, caustic. Macke's harmonious and

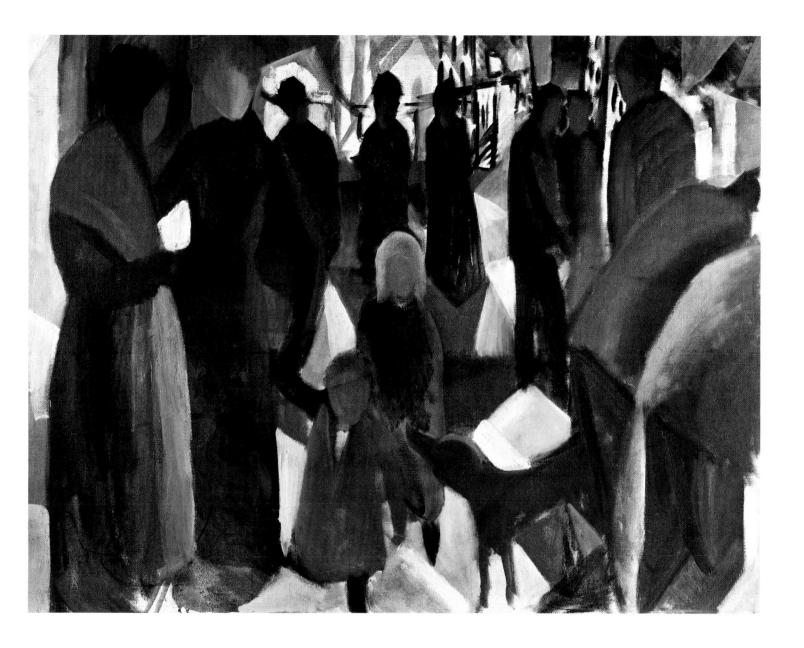

joyous view of the world as an artist was buried under the rubble of the World War. After 1918, there was no place for it.

His work remained unfinished. The sudden interruption of his development left his promise unfulfilled. And yet – there is something typical in Macke's fate. His unfinished work is symptomatic of a 20th century art which Macke himself helped inaugurate. For there is an inherent tendency to the fragmentary in 20th century art – a tendency not least induced by two world wars! It is an art fated to find its greatest perfection in that which remains unfinished.

Leave-taking, 1914
Abschied
Oil on canvas, 101 x 130.5 cm
Museum Ludwig, Cologne

August Macke: Chronology

1887 August Robert Ludwig Macke, born on 3 January at Meschede/Sauerland. His father August Friedrich Hermann Macke was a civil engineer and building contractor. His mother, Maria Florentine, neé Adolph, had been brought up on a farm in the Sauerland. Shortly after August's birth, the family move to a house in Brüsseler Strasse, Cologne, remaining there until Macke's 13th year.

1897 Schooling at Kreuzgymnasium, Cologne.

1900 Family move to Meckenheimer Strasse 29, Bonn. Schooling in Realgymnasium, Bonn. First trip to Basle from Kandern. Macke discovers Böcklin at the Kunstmuseum, Basle.

1903 Meets Elisabeth Gerhardt.

1904 Study of art at the Prussian Royal Academy, Düsseldorf. Joins 4th Class under Adolf Maennchen.

1905 Takes evening classes at the School of Arts and Crafts, Düsseldorf, under Fritz Helmut Ehmke. Works as a stage and costume designer at the Schauspielhaus, Düsseldorf, directed by Louise Dumont and Gustav Lindemann. In April, first trip to Italy with Walter Gerhardt (Verona, Padua, Venice, Bologna, Florence, Pisa, Rapallo and Bolzano).

1906 Travels in July to Holland and Belgium (Rotterdam, Scheveningen, Knocke, Ostend); in winter, visit to London and British Museum. Leaves the Düsseldorf Academy in November.

1907 In April/May, Macke and Claus Cito stay with Macke's sister Ottilie at Kandern. Visits the Kunsthalle and Printroom at Basle; first encounter with French Impressionism. In June, first visit to Paris. Enters Lovis Corinth's atelier in Berlin in October.

1908 In April/May, second trip to Italy with Gerhardt family (Milan, Ravenna, Bologna, Florence, Perugia, Siena, Pisa, Rapallo and Genua). In July, second visit to Paris with Elisabeth Gerhardt and Bernhard Koehler. Visits the art dealers Durand-Ruel, Bernheim-le-Jeune and Vollard.

1908 – 09 Military service.

1909 Marriage to Elisabeth Gerhardt on 5 October; their honeymoon takes them via Frankfurt am Main, Colmar and Berne to

August Macke, ca. 1903

Bernhard Koehler, Elisabeth Gerhardt and August Macke at Grunewald, 1908

August Macke, 1908

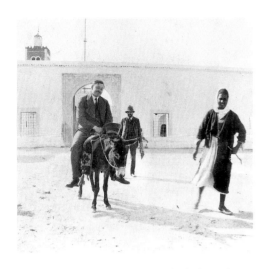

August Macke and Paul Klee with guide in front of the Barbier Mosque, Kairuan, 1914

Bonn museums and galleries. Friendship with Worringer family, Cologne. Joins the "Gereon Club", Cologne. In late summer, visit to Kandern and Thun (Switzerland). Meets Paul Klee. Work for the "Almanac" of the "Blaue Reiter". Writes the essay "The Masks". Shows three paintings at the first "Blaue Reiter" exhibition in the Thannhauser Gallery, Munich.

1912 Exhibitions in Moscow (Caro-Bube Artists' Association), Cologne (Kölner Sezession), Munich (Thannhauser Gallery) and Jena (Kunstverein).
In spring, travels to Holland (Amsterdam, Leiden, Haarlem, The Hague, Katwijk and Nordwijk). Shows 16 drawings at the second "Blaue Reiter" exhibition. Works for the "International Exhibition of the League of West German Artists and Friends of the Arts", Cologne.
End of September, travels to Paris with Franz Marc and visits Robert Delaunay. In October, sees Futurist paintings at Kunstsalon Feldmann, Cologne.

1913 On 21 January, Robert Delaunay and Guillaume Apollinaire visit Macke in Bonn. Birth of a son, Wolfgang (8 February). In March, visit to Delaunay exhibition, Cologne. Organises the "Rheinische Expressionisten" exhibition at the Kunstsalon Friedrich Cohen, Bonn. Collaborates on the first "Deutscher Herbstsalon" in Her-

August Macke on board the "Carthago", 1914

warth Walden's gallery "Der Sturm", Berlin. From October, stay at Hilterfingen, Lake of Thun (Switzerland).

1914 Beginning of April, travels via Thun and Berne to Marseille. On 6 April crossing from Marseille to Tunis with Klee and Moilliet. On 22 April, return with Moilliet via Palermo and Rome to Hilterfingen. Beginning of June, return to Bonn. On 8 August, called up for active service. On 26 September, August Macke is killed in battle.

Paris; meets the painters Louis Moilliet and Carl Hofer. At the end of October the Mackes move to Tegernsee.

1910 Meets Franz Marc. Visits a Matisse exhibition at the Thannhauser Gallery, Munich. A son, Walter, is born (13 April). Marc introduces Macke to the "Neue Künstlervereinigung", Munich. Return to Bonn in November.

1911 In February, moves into new studio in Bornheimer Strasse 88 (today 96) in Bonn. Meets directors of Cologne and

Macke family at Hilterfingen, Christmas 1913

Elisabeth, August and Walter Macke, 1912

The author and publishers wish to thank the following museums and collectors for their support and provision of photographs (with page numbers of illustrations):
Private collection, Berlin: 19, 41; Staatliche Museen zu Berlin – Preußischer Kulturbesitz, Berlin: 34; Kunstmuseum, Berne, Hermann and Margrit Rupf-Stiftung: 51; Städtisches Kunstmuseum, Bonn: 12, 17, 26, 54, 55, 73; Kunsthalle, Bremen: 48, 70; Galerie Utermann, Dortmund: 21; Museum am Ostwall, Dortmund: 1, 16, 33, 50, 61; Wilhelm-Lehmbruck-Museum, Duisburg: 29; Kunstsammlung Nordrhein-Westfalen, Düsseldorf: 62; Kunstmuseum, Düsseldorf, Graphische Sammlung: 43; Westdeutsche Landesbank Girozentrale, Düsseldorf: 27; Karl Ernst Osthaus Museum, Hagen: 49; Kunsthalle, Hamburg: 31; Sprengel Museum, Hanover: 28, 47, 52; Staatliche Kunsthalle, Karlsruhe: 65; Museum Ludwig, Cologne: 93; Museum für Kunst und Kultur-geschichte der Hansestadt Lübeck, Lübeck: 2; Wilhelm-Hack-Museum, Ludwigshafen am Rhein: 42, 44; Städtisches Museum, Mülheim an der Ruhr: 30, 32, 56, 68, 76; Städtische Galerie im Lenbachhaus, Munich: 11, 25, 36, 39, 69, 74; Westfälisches Landesmuseum für Kunst und Kul-turgeschichte, Münster: 6, 9, 14, 15, 22, 35, 45, 63, 64, 80, 81, 94, 95 and back cover; Saarland Mu-seum, Saarbrücken: 37; other sources: Artothek, Peissenberg: 53, 88; archive of the author: 89; archive of the publishers: 23, 46, 53, 57, 59, 60, 66/67, 79, 83, 84, 85, 86, 87, 90, 91 and front cover.

In this series:

- Arcimboldo
- Bosch
- Botticelli
- Bruegel
- Cézanne
- Chagall
- Christo
- Dalí
- Degas
- Delaunay
- Duchamp
- Ernst
- Gauguin
- van Gogh
- Grosz
- Hopper
- Kahlo
- Kandinsky
- Klee
- Klein
- Klimt
- Lempicka
- Lichtenstein

- Macke
- Magritte
- Marc
- Matisse
- Miró
- Modigliani
- Monet
- Mondrian
- Munch
- O'Keeffe
- Picasso
- Redon
- Rembrandt
- Renoir
- Rivera
- Rousseau
- Schiele
- von Stuck
- Toulouse-Lautrec
- Turner
- Vermeer
- Warhol